IMAGES
of America

NEW SMYRNA BEACH

IMAGES
of America

NEW SMYRNA BEACH

Lawrence J. Sweett

ARCADIA
PUBLISHING

Published by Arcadia Publishing
Charleston, South Carolina

Printed in the United States of America

Library of Congress Catalog Card Number: 2006926903

For all general information contact Arcadia Publishing at:
Telephone 843-853-2070
Fax 843-853-0044
E-mail sales@arcadiapublishing.com
For customer service and orders:
Toll-Free 1-888-313-2665

Visit us on the Internet at www.arcadiapublishing.com

*This book is dedicated to the memory of Zelia Mary Wilson Sweett.
This book is the direct result of Zelia Wilson Sweett's dedication
to collecting, conserving, and cataloguing the history of her
family and her community throughout her lifetime. The book is
a tribute to her, the information she gathered, and the collection
she nurtured—her unselfish gift to the community.*

CONTENTS

ACKNOWLEDGMENTS

This book would not have been possible if it were not for Zelia (Dede) Mary Wilson Sweett's lifelong interest in her family, her community, and people in general. Her penchant for accumulating, recording, and retaining all forms of information about her family and her community earned her a reputation as a historian throughout the state of Florida. Her collection of old photographs provided an abundant source for reproduction for professionals and amateurs alike throughout the years.

Zelia Sheldon Sams gave Zelia Mary her extensive collection of local artifacts when Zelia was in her early teens. The collection was housed in the Ocean House lobby until Capt. F. W. Sams built a home to the north of the Jane Sheldon cottage in 1907.

After Zelia completed her education at Florida State College for Women in Tallahassee, she took a swing at New York City before she returned to settle down in New Smyrna. She married S. Jack Sweett.

The collection drew a lot of attention throughout the years from archeologists, anthropologists, and historians. Perhaps the most appreciative of the visitors to the collection were the school children for whom Mrs. Sweett was always willing to show and tell about the collection of artifacts.

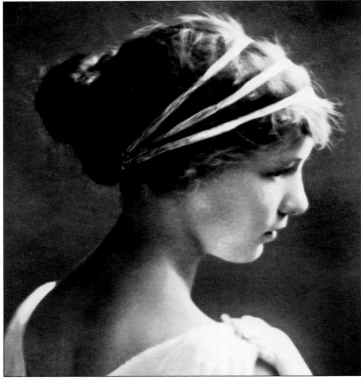

Zelia Mary Wilson Sweett
December 10, 1897–April 4, 1980

INTRODUCTION

Welcome to the idea of old New Smyrna in pictures randomly selected with few dates to confuse you. The selection of pictures is governed by what is available to me from Zelia Sweett's collection and what I have gathered. Most of the pictures presented are and have been in the public arena for years and any copyright infringements are not known or anticipated.

The history New Smyrna (Beach) is unique in the history of Florida and is a well-kept secret. The history of this area began when Ponce de Leon entered the Mosquito Inlet, briefly exploring the area before sailing north along the coast of what he named Florida.

Turtle Mound and the inlet were on the navigational charts of Florida long before anyone began land surveys in the state. Jonathan Dickinson noted a Native American village at what became New Smyrna in 1696, when he marched by to reach the Spanish outpost on the north side of the inlet. Dr. Andrew Turnbull and his crew made a serious incursion into the area when they began settlement here in 1767. There were a couple of small plantations at that time that were no match for the 1,200-plus Turnbull people that made up the British colony.

When the British period ended in 1783 and the Spanish returned, New Smyrna was reduced to a few people that never left, a few that returned, and others that took advantage of the houses abandoned by the New Smyrnans when the settlement folded in 1777. People moved out afterward due to Native American incursions, private Spanish land acquisitions, and better opportunities elsewhere.

The Spanish encouraged settlement of the Floridas by offering land grants to those who would pledge allegiance to his majesty, not practice any other religion than Roman Catholicism publicly, and improve the land over a 10-year period.

An Episcopal minister named Ambrose Hull brought a group of people to the New Smyrna area to colonize. Various reasons contributed to these people leaving. Hull stayed and obtained two land grants in 1801. The grant obtained along the river was for 400 acres, and the grant in back of the town was 600 acres. In 1830, employees of Cruger and De Peyster built a sugar mill on the property back of town. Others successfully sought land grants in the same manner, and others began but never completed the improvements and never obtained a grant.

International political climates were changing. Spain became aware the United States was going to obtain Florida one way or another, with Andrew Jackson being the prime mover. In 1817, it was a sure thing, and then rather peculiar things began to happen to property titles and such things. Ambrose Hull's grant description went from 400 acres on the Mosquito River to 1,000-plus on the Mosquito.

East and West Florida were transferred to the United States in 1821 and became a territory, and Andrew Jackson was appointed the first military governor. Florida was divided into two counties, St. Johns and Escambia, with St. Augustine becoming the county seat of St. Johns County. In 1824, Mosquito County was cut out of St. Johns County, and in 1835, New Smyrna became the county seat of Mosquito County.

Alas, the Second Seminole War began in December 1835, and what was at New Smyrna was destroyed. Even Mother Nature got into the act, destroying the new lighthouse built on the south side of the inlet. The war lasted until 1842, and the physical removal of the county offices to New Smyrna never happened. In 1842, Enterprise was named the county seat of Mosquito County.

Florida became a state in 1845, and Mosquito County became Orange County, with Mellonville designated the county seat of Orange County. In 1854, Volusia County was split out of Orange County, and Enterprise was established as the county seat until an election could be held to

determine where the county seat was to be. In 1886, an election was held, and DeLand was selected as the county seat of what had now become Volusia County.

New Smyrna was mostly deserted from 1836 until 1842 except as a staging area for troops moving into the interior. The first Haulover Canal was dug in 1847. This canal made an island out of the beachside; before, it was a peninsula, and a person could walk from New Smyrna down to Mosquito Lagoon and over to the beach and up the shore to the Club Breakers.

In 1854, Volusia County was split out of Orange County, and Enterprise was established as the county seat. In 1886, an election was called and Delanad was selected as the county seat of what had now become Volusia County officially in 1887.

After the Second Seminole War, life began again in New Smyrna. The customs collector was back at work, live oak loggers were back from Massachusetts, citrus groves were established, and things were moving right along. Urban sprawl was at work, but nobody knew what that was at that time.

Then the War Between the States began, with Florida becoming the third state to secede from the Union. During the war, there was an incursion by the Federal Navy into the estuary, which resulted in eight sailors losing their lives. This brought retaliation from the navy, with the ships randomly firing an occasional shell into the community. In 1863, a Federal gunboat was towed into position in the estuary in front of what we know as the Old Fort. The U.S.S. *Beauregard* fired 180 various types of ordnance into the community, destroying the Sheldon house on the hill; Carpenter's Tavern, which was located about where the courthouse annex is; and the stone wharf. After the war, the widow Sheldon had a smaller inn built upon the Old Fort Mound and was in business again. Her son-in-law built the first section of the Ocean House on property John Sheldon had sold to Ora Carpenter and Ora sold to Edmund Kirby Lowd after Carpenter moved to Osteen on Lake Monroe, far from the coast.

In 1877, Charles Coe started the *Florida Star*, the first newspaper in Volusia County. The newspaper is in publication today as the *Titusville Star Advocate*. The year 1887 was a very busy year in and around New Smyrna. The city was incorporated, the lighthouse was completed, the Orange City, Blue Spring, and Atlantic Railroad came to New Smyrna from the St. Johns River, and the second Haulover Canal was completed. Growth was upon us, and no one noticed its cruel forward movement. The Florida East Coast Railroad (FEC) moved through New Smyrna in 1891.

The FEC built a hub in New Smyrna in the 1920s that provided a firm, economic base for the community until the railroad strike that began in the 1960s.

The political power in the county developed in New Smyrna and held on tightly well into the 1930s. Population growth moved the political power toward DeLand, from which it moved to the Daytona area, where politics, money, and publications have kept it healthy and happy until the Deltona population started moving the power south and west. At this stage, communication is the key, and Daytona is still loud and only a little bit muted.

Pardon me for getting a little out of hand; and perhaps I lost some of you on the way. I sure hope not. If you did not get lost in these passages, I hope a lot of you will really get lost in the pictures in this book and enjoy what you find. For your information, there will be no test given on this material.

One

TOWN TOUR

New Smyrna Beach is a waterfront community, with the North Indian River flowing through the center of the community, Ponce de Leon Inlet on the north, and the Atlantic Ocean washing against the eastern side. The tourists were bound to come for the moderate climate, the river, the beach, and the hunting and fishing when they heard about New Smyrna Beach. Initially people located along the river and along the beach; as others arrived and as the locals grew in number, the housing moved inland. Local sustenance was plentiful, as the river and ocean were full of fish and the ground was fertile. The cash tree was bare, as the local economy did not generate any money. It took a long time to expand the market outside of the community to bring cash back in return for goods sold, not bartered. Truck farming and fishing brought in cash when shipped to markets outside of the community. Hotels, boardinghouses, and rental houses brought money into the community. The railroad came through town and the economy began to move upward. Shipping was available both in and out of the area: citrus moved out, and tourists moved in to spend time and money in the community. The community grew slowly and steadily into the town it is today.

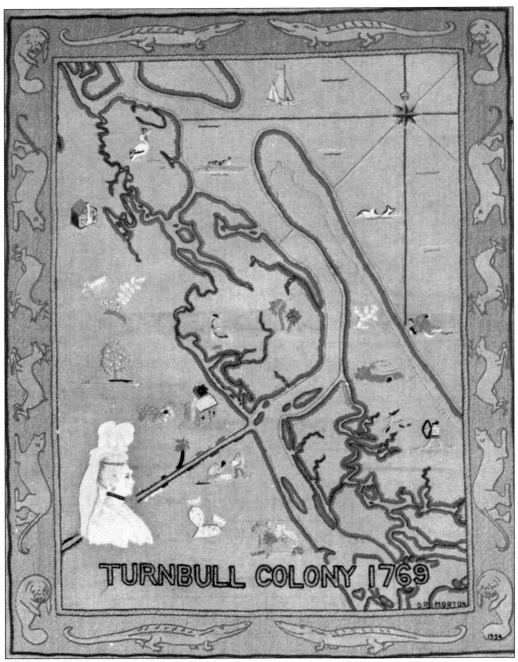

This tapestry depicts a map of the Turnbull venture during the British period of Florida history (1763–1783). Variously referred to as a colony, a settlement, New Smyrna, or Smyrnea, it exists today as New Smyrna, with the Beach added to remind tourists the city is on the shores of the Atlantic Ocean. Turnbull referred to Smyrnea, which he defined to mean New Smyrna in bad Greek. The New World called it New Smyrna.

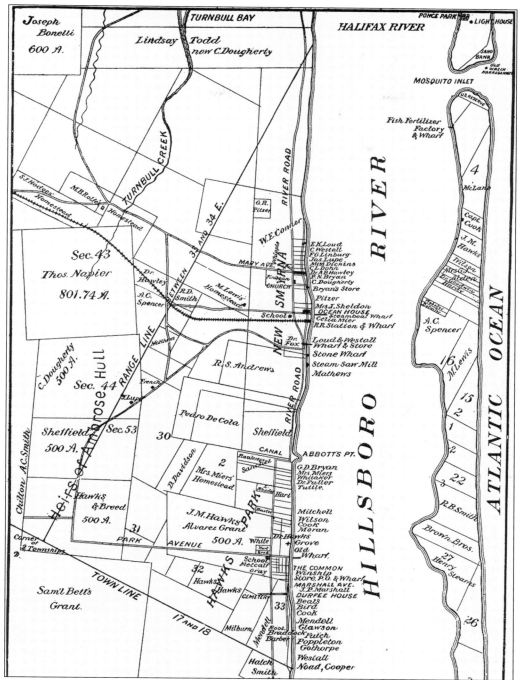

The map of New Smyrna and Hawk's Park names the property owners, residents along the riverfront. Illustrated are various homesteads and grants in the area. The Orange City, Blue Spring, and Atlantic Railroad reached New Smyrna in 1887 and is shown reaching the river at a wharf. This map was obtained from a facsimile edition of the 1887 book *East Coast of Florida*, by J. M. Hawks, M.D.

Andrew Turnbull (1720–1792) was born in Annan, Scotland, and educated in London and Paris as a doctor of medicine. Turnbull's entrepreneurial instincts awakened when he learned of the British offer of land grants in East and West Florida. Turnbull successfully promoted an adventurous plan that became the New Smyrna settlement in 1768.

George Jennings Murray learned engraving as an apprentice in London, England. He immigrated to the United States, where he obtained a ship and engaged in the settlement of Spanish East Florida by transporting immigrants. He obtained a Spanish land grant of 600 acres some six miles south of New Smyrna in 1803. He wrecked his ship on the bar at St. Augustine, ending his East Florida adventure.

Gracia Maria Rubini, the daughter of a wealthy merchant, was born in Smyrna, Turkey. She married Dr. Andrew Turnbull on August 27, 1753. Twelve children were born of their union; three of them were born in New Smyrna in East Florida. Gracia Maria died August 1, 1798. Both are buried in St. Philip's Churchyard in Charleston, South Carolina.

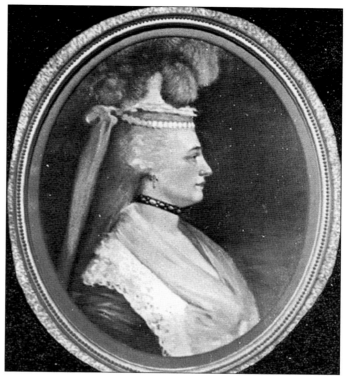

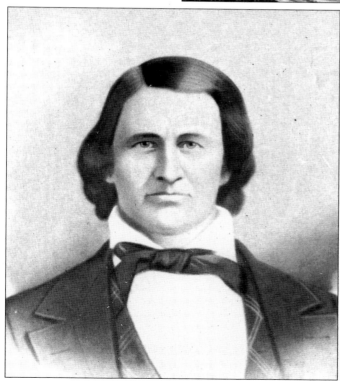

Massachusetts-born John Dwight Sheldon made his way to Florida early in the 19th century. He was physically strong, a hard worker, intelligent, and assertive. He married Jane Murray at Mandrin, Florida. They came to New Smyrna early in 1835. The Cruger and dePeyster Company employed him. The Sheldons occupied the company house built on the Old Fort Mound.

13

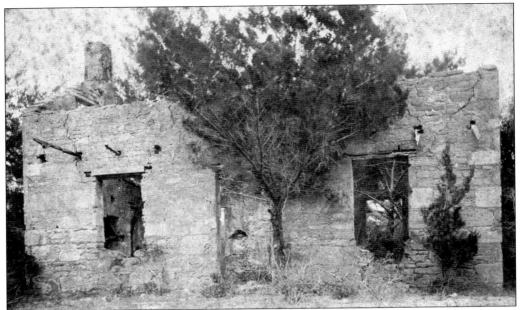

The Rock House dated from early on in the Turnbull colony. After the initial and only turmoil by the settlers was subdued, Gov. James Grant stationed a squad of soldiers in New Smyrna to maintain order as necessary, protect against Native American incursions, and to guard against attack from the sea and otherwise maintain the peace. The Rock House was removed in the early 1900s, when the railroad ran a spur track onto the property opposite the inlet to remove shell from the middens along the river.

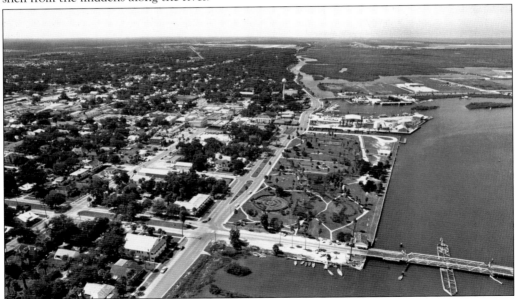

This aerial shot taken c. 1966 illustrates the area along the riverfront from north of what is now Wayne Avenue down the waterfront to the south of Lytle Avenue and the South Bridge. The first South Bridge was completed in 1924, along with the supporting causeway. The bridge house, with an office and living quarters, is to the left.

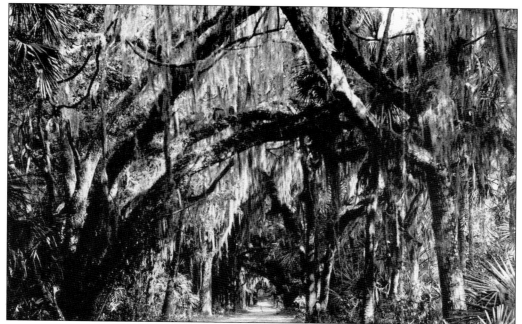

Large oak trees were plentiful in and around New Smyrna. The road to Daytona in the early 1900s meandered westward and northward toward high ground, avoiding the creeks and ponds. Spruce Creek and Rose Bay were bridged in the 1920s. Early on, the oak forests were thick enough to provide a canopy over the narrow roads.

This photograph looks north along the riverfront in New Smyrna from Ronnoc Lane. The Connor residence was located near the northeast corner of Ronnoc Lane and North Riverside Drive. The Connor home burned in the 1920s. Automobiles of the times had canvas roofs; many of the roofs had holes burned in them by the wind-blown burning embers when their owners drove them to see the fire.

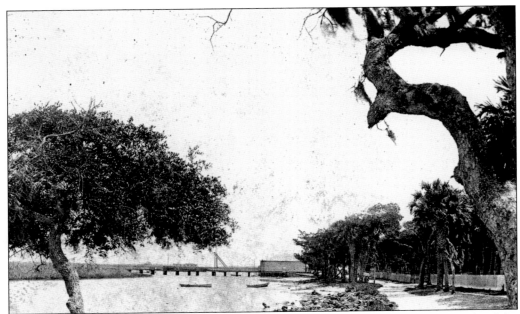

Looking to the south toward Berry's Bridge is a small drawbridge about 200 feet north of the present Berry's Bridge. The bridge was the approach to the North Causeway. The draw was built to permit Washington E. Connor's boat to pass through the bridge. Ronnoc is Connor spelled backward.

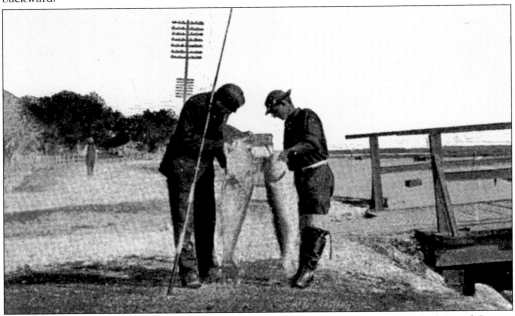

The man on the right is showing his catch at the bridge to the pier at the end of Canal Street. The telephone poles indicate this is after 1902. The Old Fort Mound is in the background, as is the bridge to the North Causeway. The man is wearing waders of sorts and probably caught the fish casting with a lure. Generally speaking, locals did not wear waders, as they fished from the banks or from boats; there were too many oysters to walk over to get to the water.

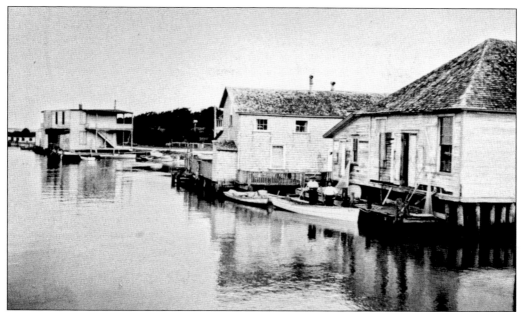

From left to right are Berry's Store, Maley's Store, and the Sons-of-Leisure Clubhouse. In the background is the Old Fort Mound. The nearest buildings were built on piling over the water and were later destroyed by a fire. The Sons-of-Leisure Club was an offshoot of the Tourist Club. Few locals were members of the Sons-of-Leisure: the list of members included one local, R. O. Vaughn Sr.

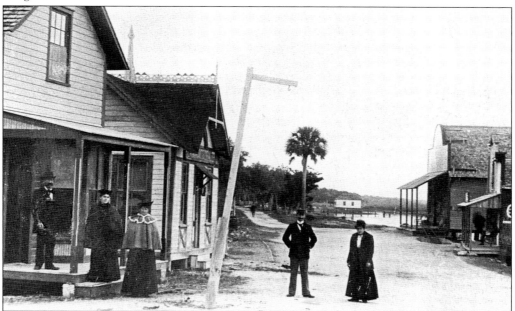

This picture was taken in the late 1800s. In those times, people wore heavy clothing. The odds are that these people are winter residents. On the right are Maley's Store in the foreground and Berry's Store, which were built on pilings over the river. The building in the background was also built over pilings and served as a home well into the 21st century.

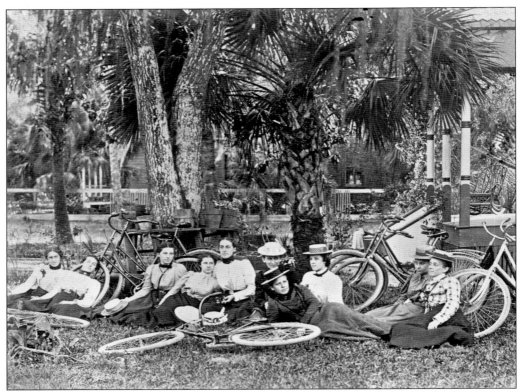

The ladies' bicycling club takes a rest after an afternoon ride. Names on the back of the picture include Clara Splice Turner, Katie Moore-Swoope, Alice Sheldon Fitts, Amelia Moeller, Ada Lowd, Tense Fox Ireland, and Guilda Bryan.

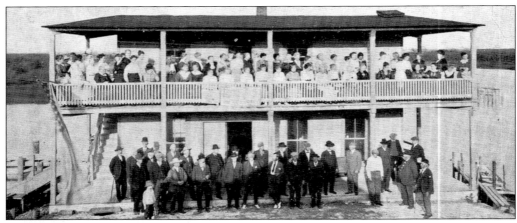

The Tourist Club organized in 1914. The club was composed for the most part of Northern tourists. They called themselves the Sons and Daughters of Leisure; the club evolved into the Anglers' Club. The Anglers' clubhouse was built in 1927 at an approximate cost of $15,000. The average membership was 40, the boathouse stored 25 boats, and the docks accommodated 25 boats.

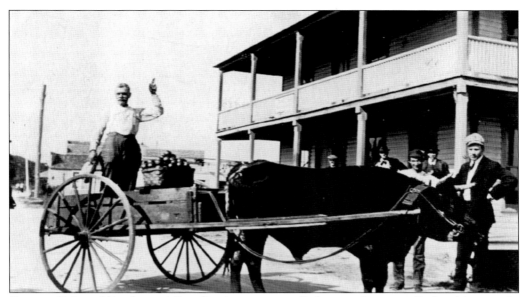

Buy my elixir and live forever! Standing in an oxen-pulled cart, a drummer displays his wares in front of the Tourist Club building. It is too late to determine if he sold any of his wares, and with no known living evidence of his product's promise, we can only speculate as to how brisk were his sales or effective the elixir.

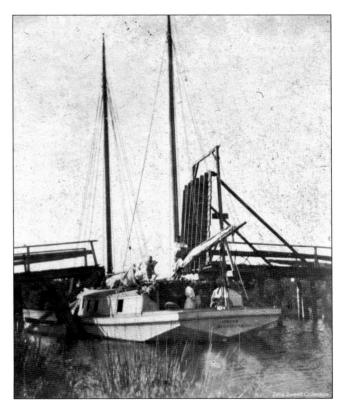

The draw is up on Berry's Bridge to let the *Orion* through. The draw was raised by hand turning a large wheel to reel the draw span up and open to boat traffic. Washington E. Connor had the draw span built in order to get his boat to his home north of the bridge. Local telephone service was provided in 1902 and to Coronado Beach in 1918. Electric service was provided in New Smyrna in 1912 and Coronado Beach in 1919.

19

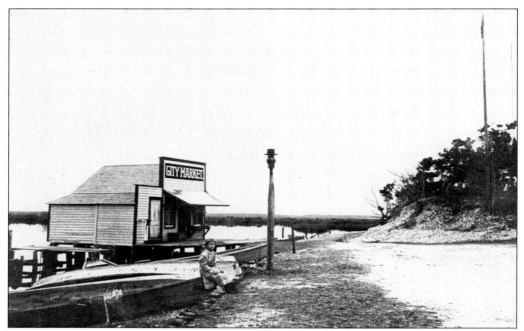

The city market stood on pilings at the side of the yacht basin facing the north end of the Old Fort ruins. There was a pier at the back of the building to supply the fish market. Later the Sons-of-Leisure boating and fishing club used the building until a two-story building was built, also on pilings, north of the city market. The Sons-of-Leisure and the Tourist Club shared use of the larger building.

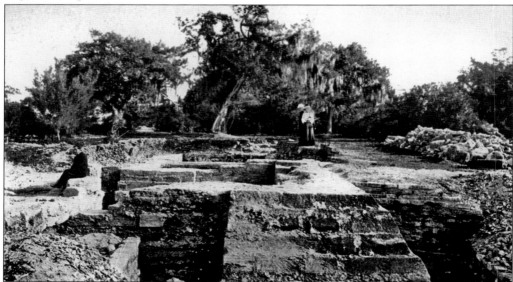

The postcard illustrates the ruins known as the Old Fort at the beginning of the 20th century. This was after the second Sheldon building was torn down and before the Works Project Administration touched up the ruins in 1935–1937. A lot of changes were made. If any records were kept as to the changes, they have not been found. This view is from the north to the south before any attempts were made to clean up the area.

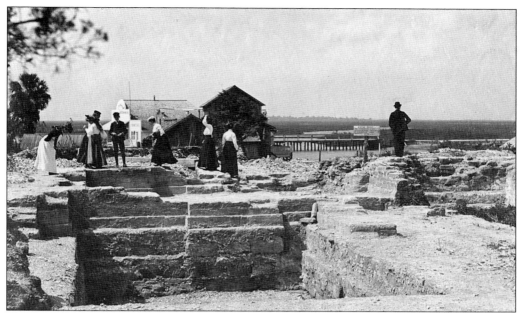

Whether the photographer took advantage of the situation or it was posed, this is an excellent representation of the clothing of the times. The Old Fort is partially excavated. The last structure to be built on the ruins is gone. Recognition of the historical value of the ruins is acknowledged by the sign. To the back right is the bridge to the North Causeway.

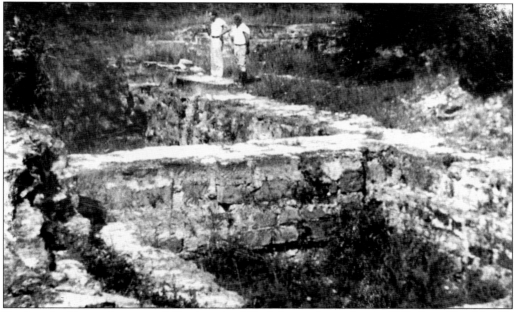

During the Depression years following the fall of the stock market in 1929, Pres. Franklin D. Roosevelt and the Congress of the United States created various programs to provide productive work and survival income for the many jobless Americans. One of several local projects of the federal Works Progress Administration (WPA) was the work done on the Old Fort. This picture was taken before the work started.

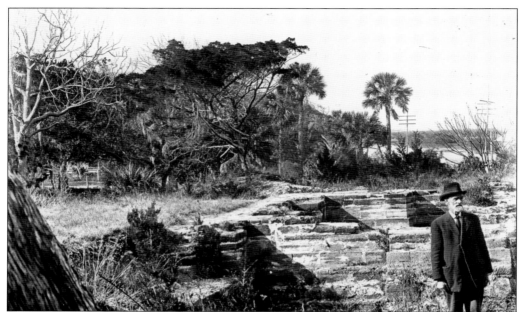

This early picture of the Old Fort looks from south to north prior to extensive excavation and reworking by the WPA. The Old Fort has been a mystery for years. The foundation was built into a Native American midden. When it was begun or why is not known. There is reasonable speculation based upon the Duncan Papers that the foundation was for a house for Lady Duncan, an investor in the Turnbull venture.

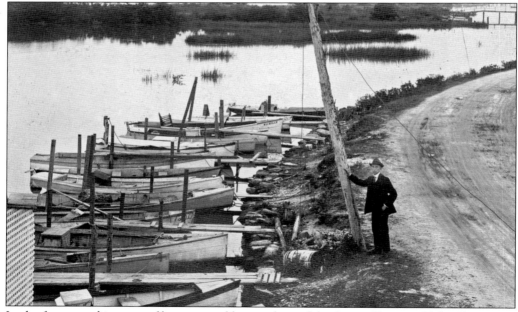

In the foreground is a row of boats owned by members of the Sons-of-Leisure Club. The picture was taken from the second-story porch of the clubhouse facing south. Around the bend, between the Old Fort Mound on the right and the basin in the upper right, is the pedestrian bridge at the foot of Canal Street used to cross the creek to reach the river.

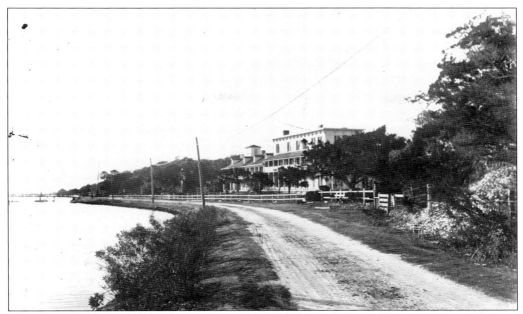

This picture looks toward the Ocean House along Hillsborough Street. The street grew in front of the Sams properties that extended to Washington Street from Canal Street. Public usage invoked proscriptive rights, and the street became public property. The Old Fort Mound is on right, and the Municipal Marina is now located on the left.

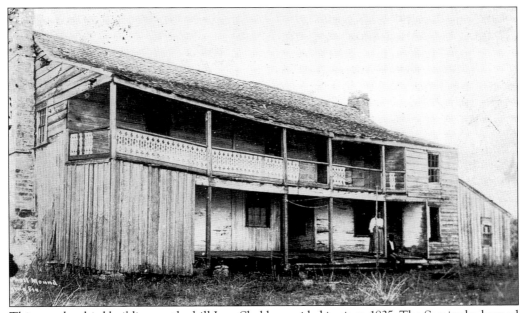

This was the third building on the hill Jane Sheldon resided in since 1835. The Seminoles burned the Cruger de Peyster Company residence at the beginning of the Second Seminole Indian War, soon after, the Sheldons left for other parts. The Federal Navy destroyed her home during the War Between the States. The termites took this building quietly.

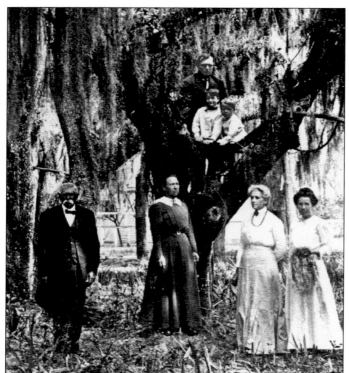

From left to right, Francis William Sams and Zelia Sheldon Sams pose with their daughters, Anna Zelia, Cornelia Jane. Sons Frank, Jack, and Harry are in the tree. F. W. Sams was active politically; he was mayor at one time, elected to the Florida Senate for three terms, and superintendent of the Houses of Refuge for the shipwrecked from Charleston, South Carolina, to Key West, Florida.

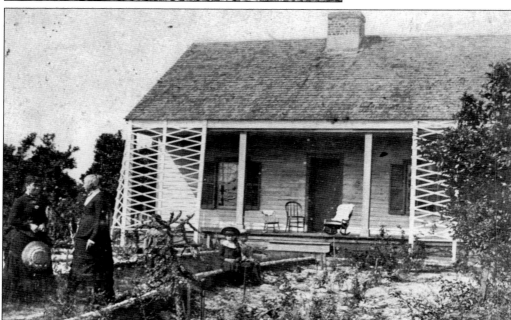

Mrs. Fulford visits with Jane Sheldon (second from left) as Mrs. Sheldon's grandchildren Edward, Zelia, and Francis Wilson watch the camera. Jane Sheldon's cottage was located north of the Ocean House. The large hickory tree at the north end of the courthouse annex is located near where the front of Jane Sheldon's cottage stood.

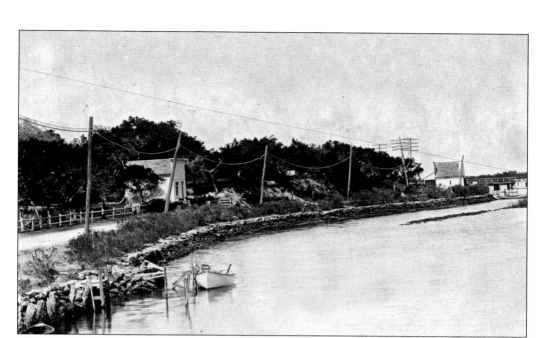

The boat is moored in front of Capt. Frank Sams's home, located out of the picture to the left. The building pictured, at one time a tearoom, was located on what became the south corner of North Riverside Drive and Julia Street. The Old Fort is in the background. The city market is in the distance, and Berry's Bridge can be seen to the far right of the picture.

On the left is the Ocean House, in the center is Jane Sheldon's cottage, and on the right is Captain Sams's home. The Ocean House was begun in 1868 and razed in 1946. The Volusia County Court House Annex is located where the Ocean House stood and covers to about the center of where Jane Sheldon's cottage stood. Captain Sams's home occupied the corner lot. Jane Sheldon's cottage was built after 1895 and razed in the 1950s.

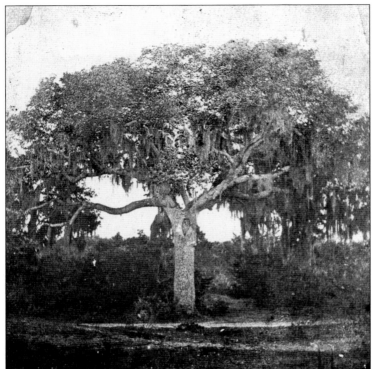

The Cannon Ball Oak is still standing in Old Fort Park even after three hurricanes. The oak was stressed and lost some limbs, but it is still there standing as tall as when it caught a cannon ball in its trunk in 1863. The large scar at the fork of the tree in this photograph has grown over and almost disappeared. The Sheldon house stood between the tree and the warship.

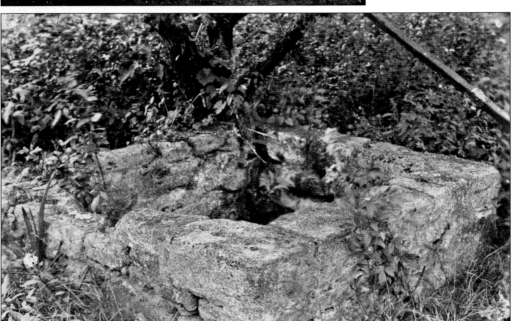

Typical of the wells of the 1800s, this type of shallow well served families adequately for many years. A well originally could be dug a depth of a few feet and supply a sufficient supply of water for a family. As the population increased, more wells were dug, and the water pressure was reduced. Ground wells were dug deeper, until it became impractical to dig farther.

Julia Dilzer (in front) and Margaret Knapp wade in the canal in front of Julia's home on Canal Street. Not much later, Julia Dilzer fell from a tree and suffered an injury that crippled her for life. She taught high school for many years, obtaining her master's degree from Northwestern University. She taught English and was not very tolerant of slackers.

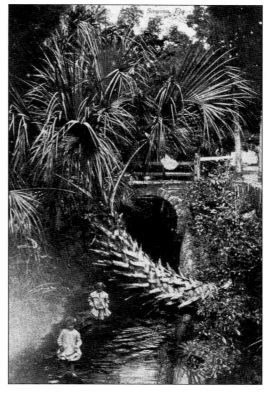

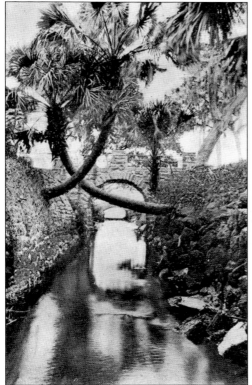

Fred Van de Sande took this classic picture of the Turnbull Canal. The photographer had to stand in the canal to take the picture. The nearest pedestrian bridge is the path to the Ocean House. The far bridge is at Hillsborough Street, now North Riverside Drive. The coquina-lined walls are quite well defined. The canal was covered by a sidewalk in 1923–1924 all of the way to Myrtle Avenue.

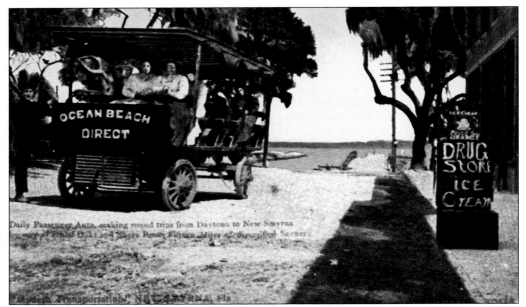

Public transportation in New Smyrna was limited to the railroad, and some jitneys provided by independent operators or by the hotel operators. The slip at the end of Canal Street is in the background the postcard. In this case, the jitney probably came down from Daytona and returned periodically for transportation between towns.

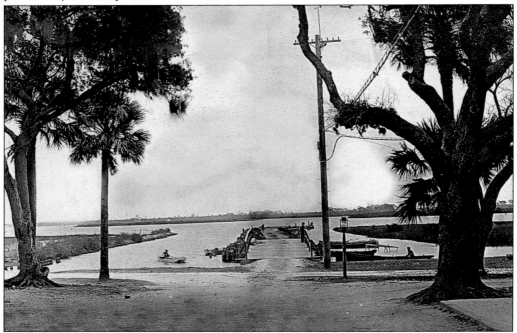

This image shows the slip at the foot of Canal Street after it was dredged. On the horizon can be seen the Detwiler house on the beachside. The slip on the left, into which the Canal Street Canal empties, is still in use. The point to the left is where the Gulf Oil Bulk Plant was located and where the Captain's Quarters is now located. The pedestrian bridge to the fill is center front.

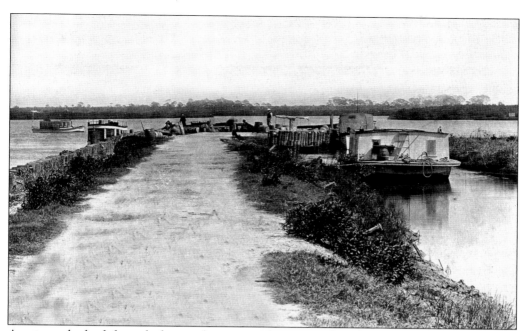

A cut was dredged through the marsh to access the estuary directly from the creek crossing the end of Canal Street from north to south. The dredged material was used to make a causeway. A pedestrian bridge initially accessed the causeway. A pier was built at the estuary side to accommodate commercial and privately owned boats.

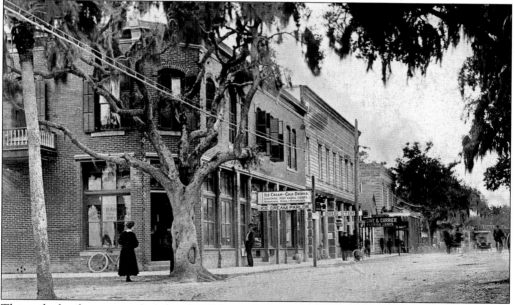

This is the bank corner at Canal and Hillsborough Street at the end of the 19th and the beginning of the 20th centuries before it was paved. Bookkeepers had to balance the books the hard way, with adding machines from written entries. They did not leave work until the ledgers balanced. The drugstore was for prescriptions. A doctor usually owned the drugstore. The ice cream parlor was a popular place for all.

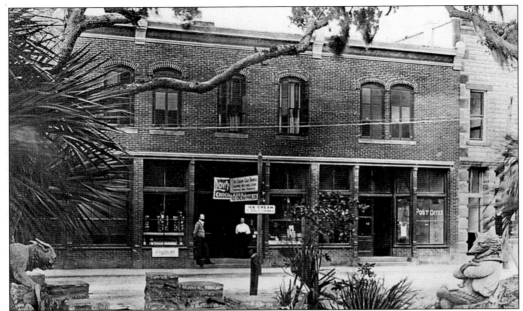

This view looks over the Ocean House pedestrian bridge to Canal Street. The Smith building housed a bank and was on the corner of Canal Street and Hillsborough Street. The building also housed a bank, Ritzy's Sundry Shop, and a post office. The cement-block building on the right belonged to John C. Maley and housed Maley's Hardware Store downstairs and a funeral parlor upstairs. The Smith building was razed in 1939.

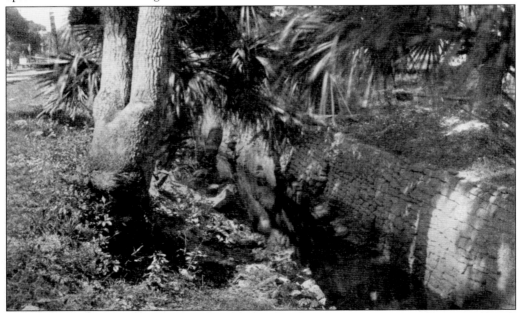

The Canal Street Canal was built by the Turnbull colony. The sides of the canal were lined with hand-hewn coquina blocks slanted back to keep the dry sand from intruding. The bottom of the canal was not lined. John Sheldon sold property adjoining the canal to Ora Carpenter but retained the right to remove the coquina blocks at a later date.

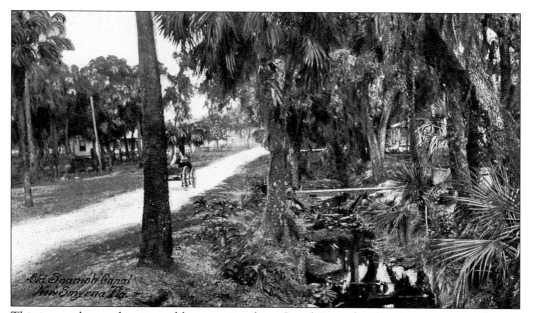

This image shows what it was like to cruise along Canal Street heading into town to sell some farm products and then to pick up some needed supplies before heading home. The board paths to reach the homes across the canal were tricky to navigate, and most people used the back roads to reach their homes with any bulky items.

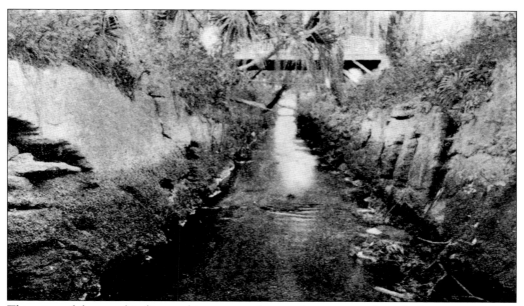

This view of the canal indicates this area was dug to a large extent through the coquina strata. There appears to be some hewn blocks along the wall, in contrast to the classic canal picture. The Canal Street Canal does not appear on the maps dated 1771 received with the Duncan Papers.

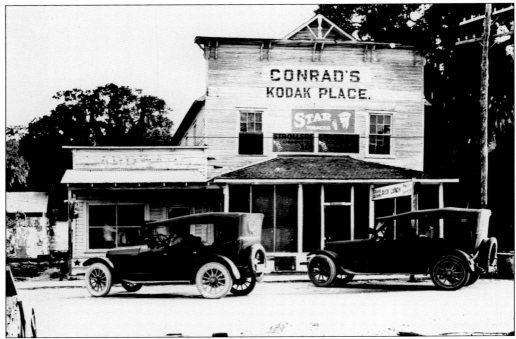

Conrad's Kodak Place is located at the southeast corner of Live Oak and Canal Streets. This building at one time housed the second school in New Smyrna. Henry D. Conrad and his wife, Maude, had a home on North Orange Street. Conrad was a seasonal photographer, spending his time between New Smyrna in the winter and the North in the summer. He retired in New Smyrna. Leroy C. Chisholm, barber, is seen though the window at work in his trade.

The Woman's Club is on the right in the picture. The streets were paved and curbed in the 1920s, during the real estate boom. A number of east and west streets on the beachside had sidewalks laid on either side.

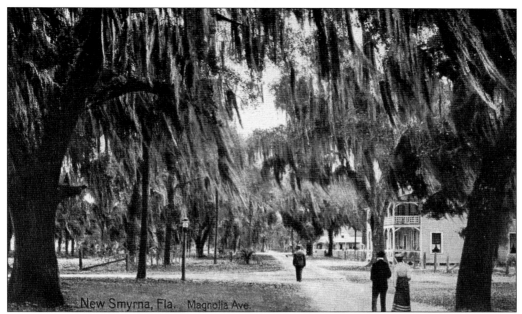

New Smyrna, Fla. Magnolia Ave.

The Turnbull Hotel on Magnolia Street was a block or so south of Canal Street. This building is not identified in many photographs of the era, and information about this building is lacking. It was a wooden structure, and the picture indicates it was built off of the ground, which distinguishes it from the Palms farther down Magnolia Street.

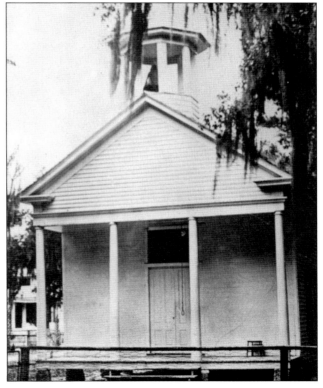

The Union Church was the first church built in New Smyrna after the Turnbull colony. The church was on property donated by Jane Murray Sheldon. The deed, dated April 6, 1875, said the land and building thereon were to be held by trustees and their successors for the use of the inhabitants of New Smyrna as a place of worship for the Presbyterian, Methodist, Episcopalian, and the Baptist churches. The Reverend C. G. Selleck conducted the first services on Christmas Day, 1875.

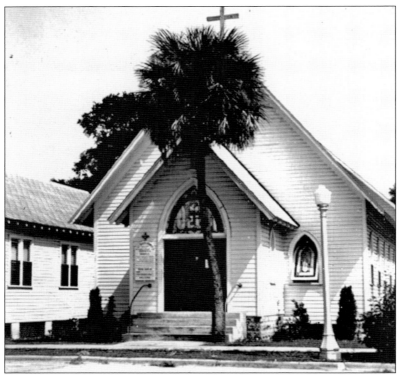

The Episcopal church building was built on the northeast corner of Palmetto and Downing Streets in 1907. The building was moved to 1650 Live Oak Street in 1977. The first activity of the Anglican Church in Florida was during the British period. The Reverend John Forbes was licensed to the plantations of East Florida, including the Smyrna settlement, on May 5, 1764. Forbes was one of several so assigned.

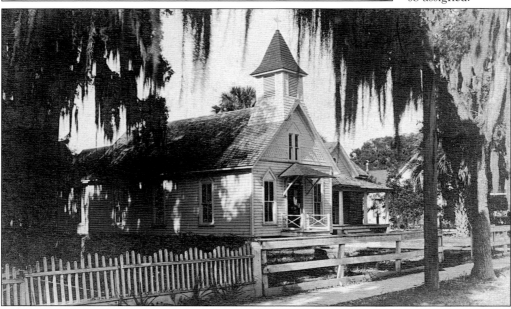

The first Catholic church in New Smyrna was established during the British period (1768–1783). Fr. Pedro Camps came to East Florida with colonists from Minorca. No physical evidence exists to support written statements that a Catholic church was built in New Smyrna during the British period. Father Camps stayed with the colonists and went with them to St. Augustine where a church was built.

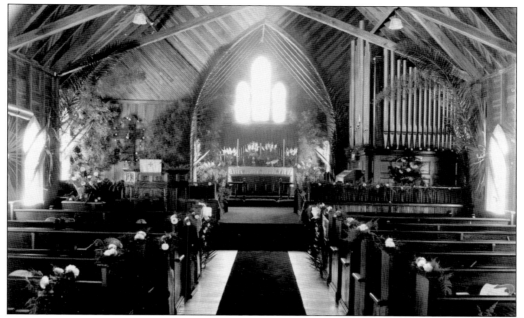

This inside view of St. Paul's Episcopal Church was taken during the 1930s. There was a parish hall and a house for the minister on the property. The lack of parking space forced the removal of the church to another location. The removal of the church aroused some complaints. One lady complained, "They stole my church!"

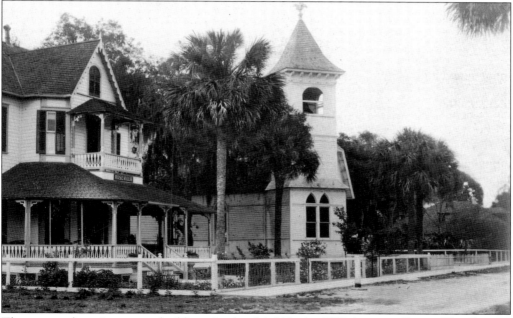

There were three important buildings in the third block of Washington Street. The Connor library building was built in 1901 and moved to the Old Fort Park and renovated by the city. The Congregational church was razed and replaced by a concrete-block structure. Albert Moeller built Rose Villa, and it is the only one of the three buildings left in the block.

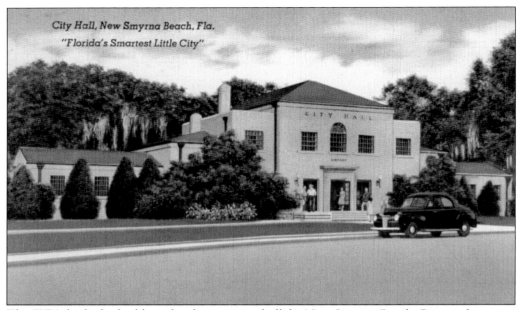

City Hall, New Smyrna Beach, Fla.

"Florida's Smartest Little City"

The WPA built the building that became city hall for New Smyrna Beach. Pieces of coquina stone were mixed into the cement to form the blocks. This gave the exterior of the building a unique look to go with the stone indigenous to the area. The building was to be used as a cultural center and also to house the library, and it did so for several years.

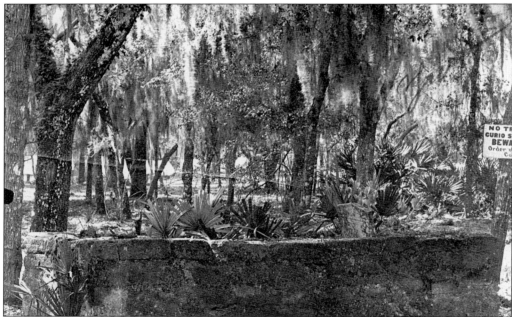

The picture is as hazy as information about the graves of the many colonists that perished during the era of the Turnbull colony. Over 700 people died, and there are no graves to indicate where the bodies lie. There is no known evidence of a cemetery and no information as to how the bodies were handled after death. This later, aboveground crypt occupied a place where the Fish Memorial Hospital now stands.

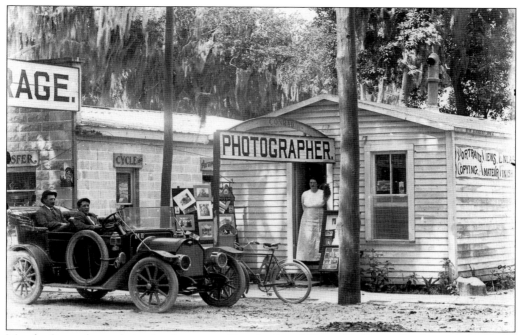

Maude Conrad stands in the doorway of her husband Harry D. Conrad's photography shop. Conrad operated from a number of different locations. He was a seasonal photographer and rented a location for the season. This building was located on North Orange Street.

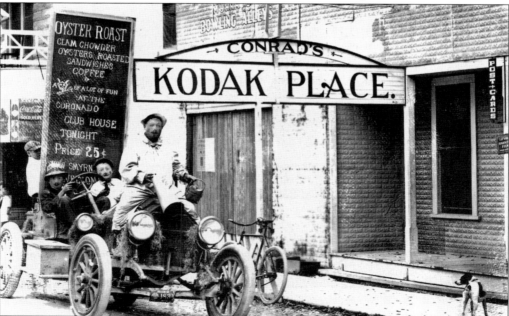

Some of the locals clown it up to sell tickets for an oyster roast at the Coronado Beach Clubhouse. The dog seems a bit wary of these guys. Conrad occupied various buildings around town, this location had been the fire station. The boarded-up section housed Murray's bowling alley at one time. Could that be Mr. George H. Werfelman's car, and is he in it?

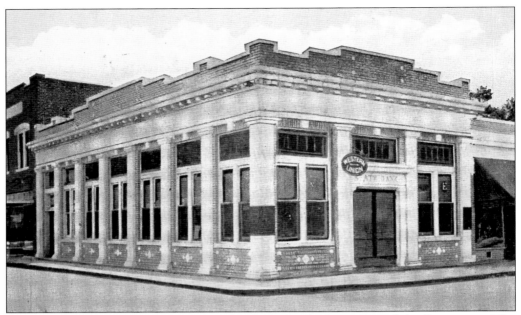

This building housed a bank that went bankrupt at the beginning of the Depression. The building became the second home of the Bank of New Smyrna after it was organized in 1936. Capitalization was in the neighborhood of $1 million when the bank was organized. The bank was of vital importance to the economic growth of the community over the years.

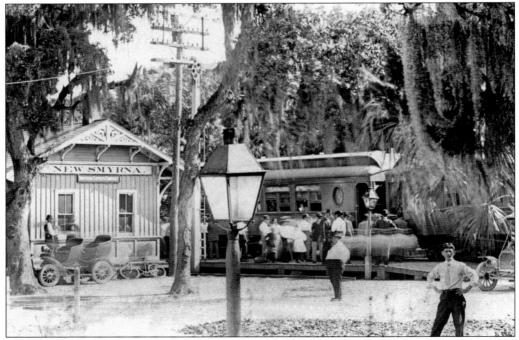

The first Florida East Coast Railway (FEC) passenger station was on the east side of the tracks just south of Canal Street. As railroad traffic increased, a larger station was built on the west side of the tracks. The old station was used as a distribution point for shipping citrus fruit in season.

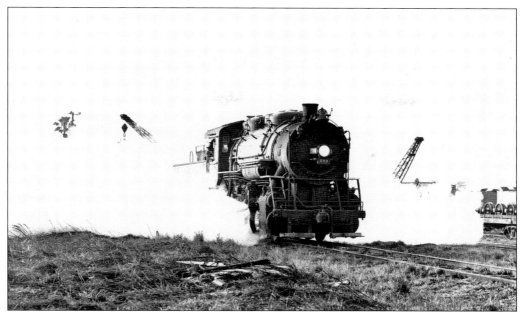

In 1926, the FEC established a railroad maintenance and repair facility in New Smyrna creating great economic stimulus for the town. The railroad was a major source of employment for the area well into the 1960s. A strike that lasted for years resulted in the elimination of passenger service. On the left of the picture is the coal chute, which was dismantled in 1916.

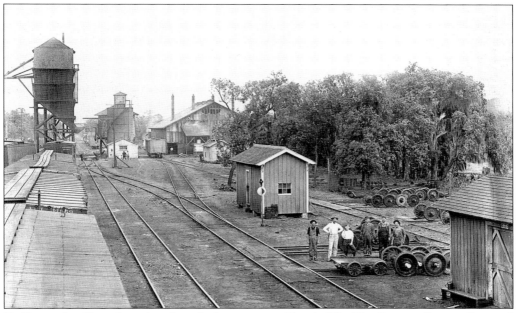

Huffing and puffing, the railroads made their way into Florida. The Blue Springs, Orange City, and Atlantic Railroad (BSOC&A) was the first railroad to reach New Smyrna in 1887. The Flagler system made its way to New Smyrna in 1892. The BSOC&A brought freight and passengers from the St. Johns River to New Smyrna. The FEC brought goods and passengers right to New Smyrna with no transfers.

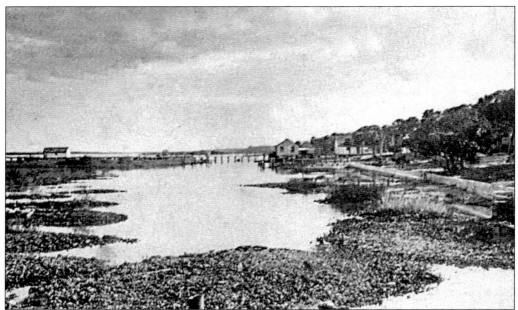

This image looks to the south from the south slip at Canal Street before the area was filled in to make a park. The normal tidal range is about 2.5 feet. There are six hours and 20 minutes between high and low tide. The tide changes from high to low twice in 24 hours. The tide is effected by the wind, and can easily range five feet between high and low water during the month.

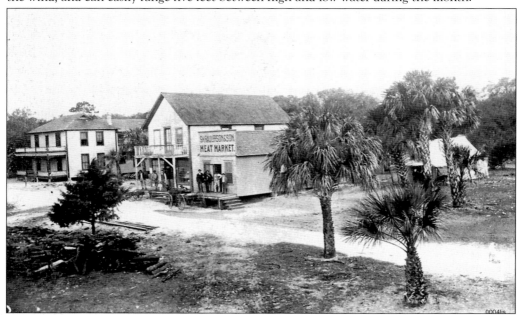

The Raulerson Meat Market gave way to the Shryock building. The house on the left of the picture is located at 420 South Riverside Drive and was built by Peter Paul, a Scandinavian seaman shipwrecked near New Smyrna. His son became a pharmacist and married Cornelia Smith of New Smyrna. Cornelia Smith became the tax collector of Volusia County and served for 40 years, as had her father.

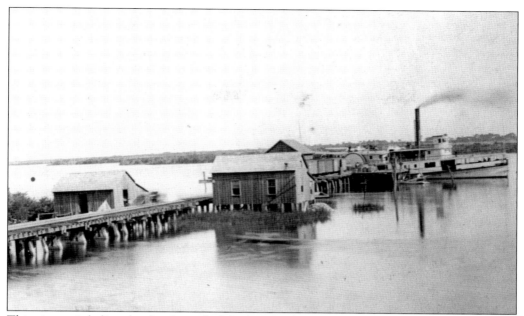

This picture is believed to be the end of the line for the BSOC&A at the trestle located at the foot of Lytle Avenue in 1887. The picture may be in question, but the railroad's eastern end was at a wharf at the end of Lytle Avenue, as attested by maps of the period.

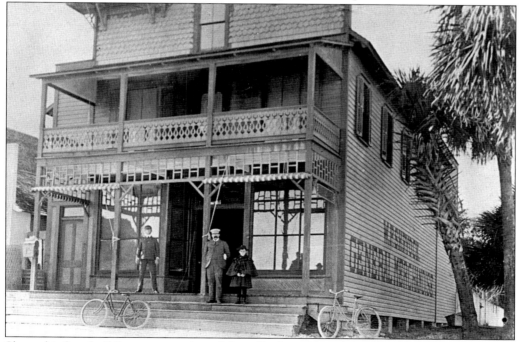

Shryock's first building was purchased from Rush and was located at the corner of South Hillsborough Street and Lytle Avenue. Later a well was dug to the north and to the middle of the building. Shryock operated a general store and mercantile operation and owned a fish house at the end of the pier in front of his store.

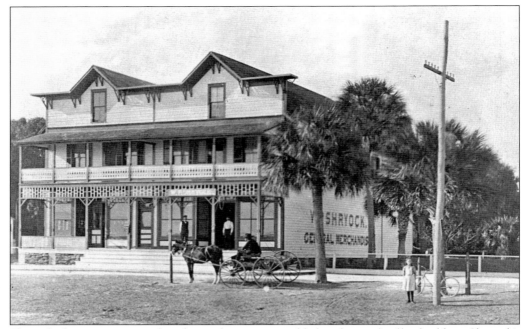

Shryock's business prospered, and a similar wing was added to the south of his building. Shryock's building was converted to an apartment house. It stands today to the south of the Harris Saxon Bridge. When Shryock built his building, it was in the business center of the community.

Local photographer A. E. Dumble had his models pose around the flow well near Shryock's store. The well was a convenience for years. People caught the water as it flowed from the pipe. The animals drank from the pool. The well was at the side of Lytle Avenue. Lytle Avenue was widened, and soon afterward, the well stopped flowing and was covered over by a sidewalk.

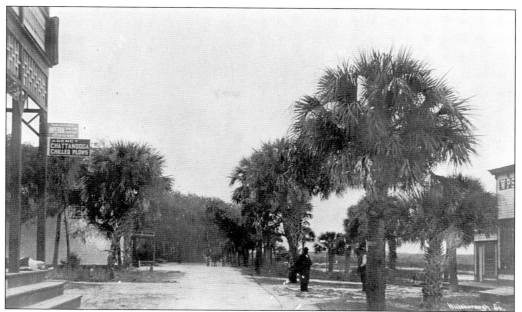

Standing in front of Shryock's store on South Hillsborough Street and looking to the north across Lytle Avenue, the approach to Shryock's Pier is on the right with the fish market. To the left in the background is Mr. William P. Wilkinson's building, which housed the post office prior to moving to Sams Avenue. Mr. Wilkinson was the postmaster for many years.

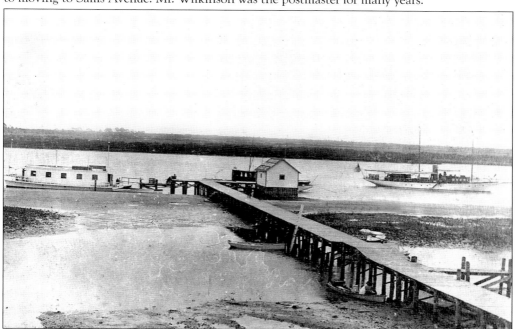

Shryock's pier was subjected to many changes over the years, until it finally disappeared in the 1930s. This picture shows the pier at its best. One boat is anchored in the channel, another is alongside the pier in front of the fish house, and another is tied alongside the north section of the pier. A fisherman in a boat is fishing next to the piling where the bridge is elevated.

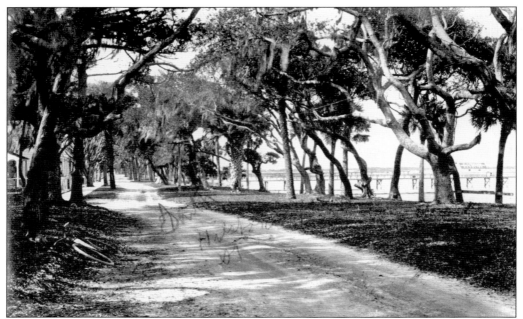

Looking north on Hillsborough Street before it was paved, Shryock's pier is in the background with the fish house at the end. Hillsborough Street became Riverside Drive, Mosquito Inlet became Ponce de Leon Inlet, and the estuary became the Indian River North as time passed.

Seen here is the last of the Old Stone Wharf as it slowly disappears. Federal bombardment in 1863, coquina removed for building, amateur archeologists, vandals, souvenir hunters, metal-detector adventurers, boat wakes, storms, and Mother Nature have all taken their toll. The wharf was built during the British period (1763–1783). Surveyors use a metal pin at the landward foot of the wharf as a benchmark for surveys of New Smyrna.

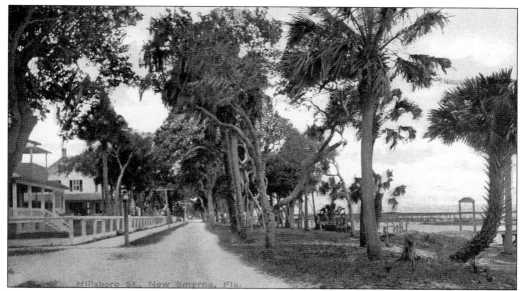

This postcard picture is closer to Canal Street and shows what is now the Night Swan Bed and Breakfast. The many long piers attest to the fact the estuary was shoaled up far from shore for many years. Preservationists can take heart in the fact the building has been well cared for over the years and that the present owners are taking such good care of the property.

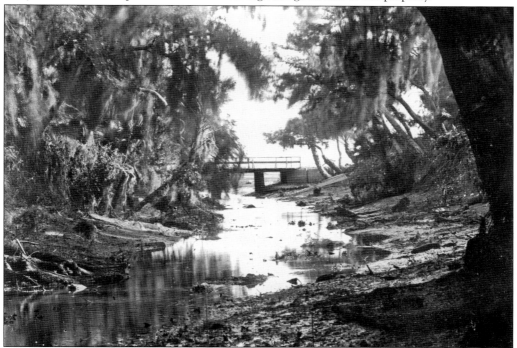

This creek appears on the de Brahm map of 1773. The tidal creek was incorporated into the Turnbull colony canal system and named the Gabordy Canal. The canal is presumed to be named after one of the colonists or a later property owner. The canal separates New Smyrna from Hawks Park (Edgewater). There was an Native American mound on the south side of the canal.

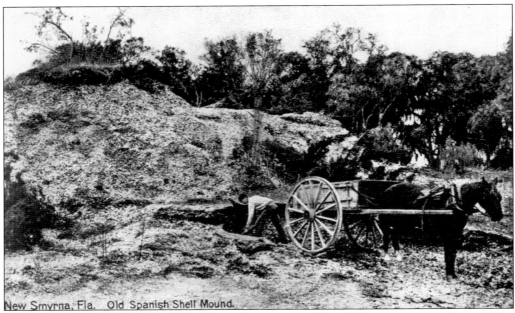

New Smyrna, Fla. Old Spanish Shell Mound.

The man is removing shell from the Native American midden for his own use, maybe as fill for a drain field for a septic tank. Necessity is generally the mother of invention and creates uses for almost all of nature's offerings. The Native Americans ate the oysters and discarded the shells. The shells accumulated into mounds called middens as time passed.

This sulfur-water flow well was located at the foot of Park Avenue east of the Strand; it no longer flows. A foundation remains as a reminder of the past. Some people believe it is healthful to drink, while others prefer to risk their health by avoiding drinking the sulfur water at all.

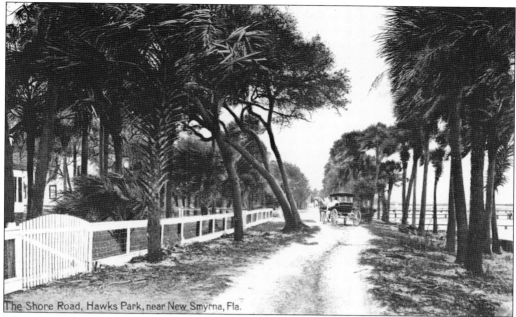

The Shore Road, Hawks Park, near New Smyrna, Fla.

The postcard was printed in Germany. Oyster beds covered the foreshore. The accumulation over the prehistoric years of these oysters, living and dead, resulted in a compact mass of oyster-shell debris several feet thick. This debris created a hard surface that supported narrow-wheeled vehicles rather well.

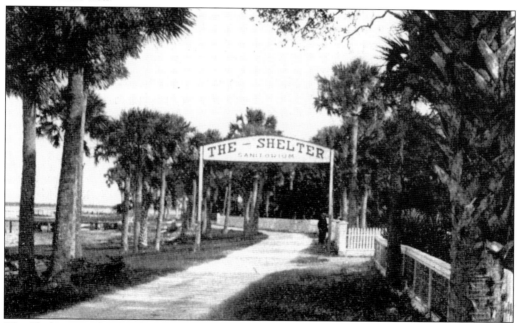

The Shelter was the first hospital in the area and was located in Hawks Park. The hospital was unique in several ways. The operating room was on the top floor and difficult to reach climbing the stairs with a stretcher. The operating room was not well lit and depended upon sunlight shining through skylights to enhance the illumination.

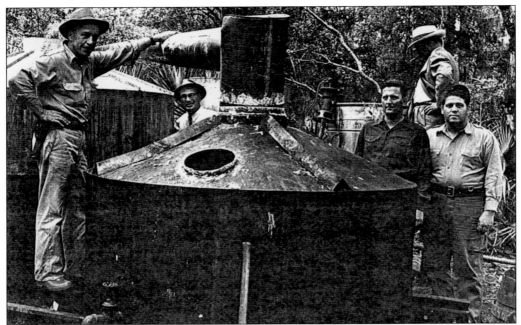

This large whiskey still was found in the woods on the north beach after 1945. Constable Russ Galbreath stands on the left side of the still. Robert McCarthy is on the right side, and Julian White stands beside him. The others are not identified but include a couple of federal agents. The still and its contents were destroyed.

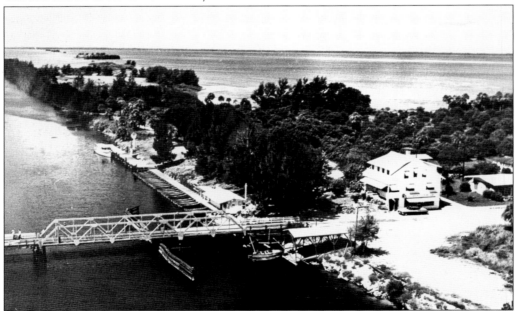

The Haulover Bridge at Allenhurst is seen here with the fishing camp still intact. Allenhurst was one of the best spots to start from; fishermen could fish the Haulover Canal, the Indian River Lagoon, or the Mosquito Lagoon at their pleasure. This was the second Haulover Canal, finished in 1887. NASA took over this area along with land and villages almost up to Oak Hill.

Two

Ocean House

The Ocean House was built in 1868, beginning as a boardinghouse. It grew into a hotel of 50 rooms. Edmund Kirby Lowd and his wife, Victoria Sheldon Lowd, built the first section of the Ocean House and managed the property until they sold it to Francis W. and Zelia Sheldon Sams in 1883. Sams added two wings and turned the hotel into a winter tourist and sportsman hotel/lodge. Sams ran the hotel for years and then turned over the management to his sons. At his death, the youngest son inherited the property and leased out the operation. The hotel died the death of old buildings and new times and was torn down in 1946.

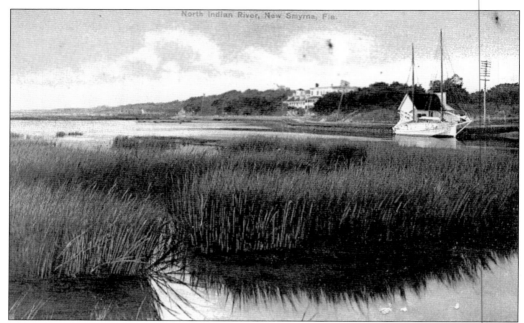

This view looks from the North Causeway south toward the Ocean House from about where the Anglers Yacht Club is today. The boat is docked alongside the fish market. The cross arms on the telephone poles indicate this picture was taken after 1916. The marsh to the south of the causeway was filled in the 1920s when the shrimp houses were built.

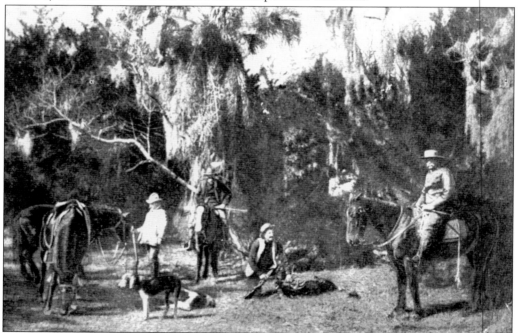

Pictured is a deer hunt near New Smyrna in the 1890s. From left to right are Gerard Stuyvesant of New York City, sportsman and guest of the Ocean House; E. J. Stewart, guide; T. J. Murray, county commissioner; and Capt. Frank W. Sams, owner and proprietor of the Ocean House.

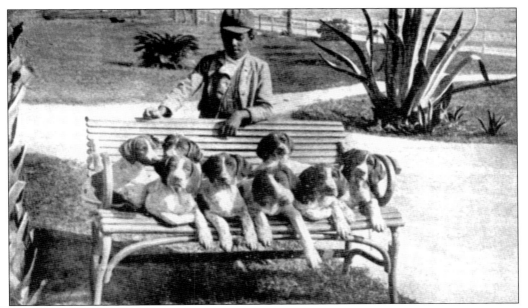

Shadrach Meeks watches over the Ocean House hunting dogs as they are posed for a publicity picture. This picture was attached to the bottom of glass ashtrays that were distributed by the hotel management.

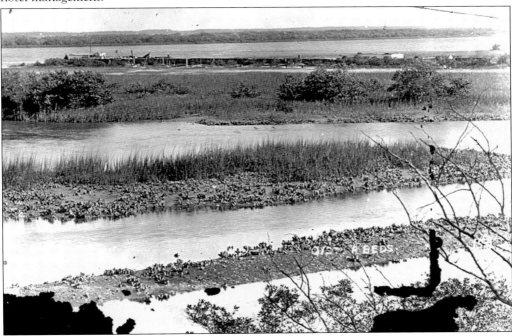

The Captain's Quarters now stands on land in the upper left corner of the picture. The sliver of water across the top of the picture leading to the river is the slip at the end of Canal Street. The salt marsh and oyster bars approaching the slip were covered with dredged material from the river. The first Gulf Oil distributor in New Smyrna, Nettie V. Turner, was located at the river on the north side of the slip and later sold her interests to Charles H. Sams.

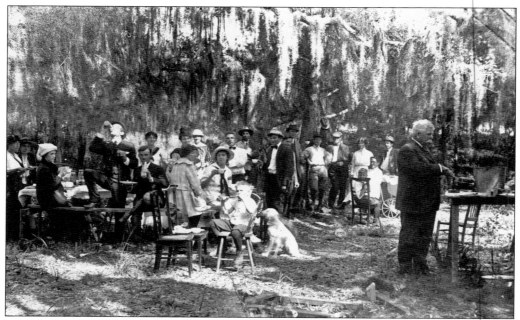

Capt. Frank Sams stands at the grill as his family gathers for a picnic. Sams was prominent in the community and the owner of the Ocean House. He served as superintendent of the Houses of Refuge from South Carolina to Key West, a city commissioner, mayor of New Smyrna, a state senator for three terms, a dedicated sportsman, and an investor.

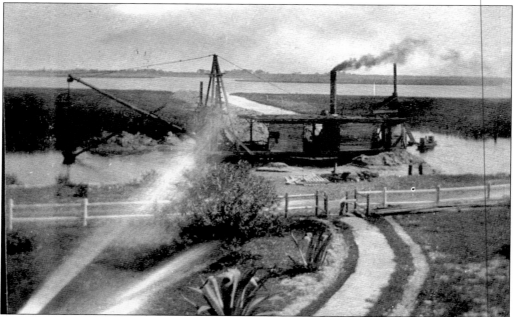

In 1901, the slip at the end of Canal Street was dredged as was a channel to the basin to the north. This made navigation from the basin and from the center of town much easier. The new channels led to a pedestrian causeway and bridge to the river at the foot of Canal Street on both sides of the slip.

The fox and the cat statuettes were given to Captain Sams as a gift from some friends who were gifted with them when a friend brought them home from a trip to Europe. Capt. Frank Sams felt it appropriate to place them at the south entrance fronting the canal and the street. Captain Sams's son, Murray Sams Sr., gave the statuettes to Rollins College in the 1950s. The cat is missing and perhaps destroyed.

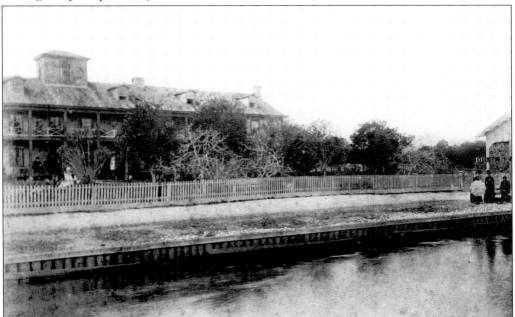

Edmund Kirby Lowd purchased property from Ora Carpenter and moved from the Lowd Mound (now called Seminole Rest) at Oak Hill to build the Ocean House in 1868–1869. Edmund Kirby Lowd built the first section of the Ocean House and operated it as a boardinghouse with the help of his wife, Victoria Sheldon Lowd.

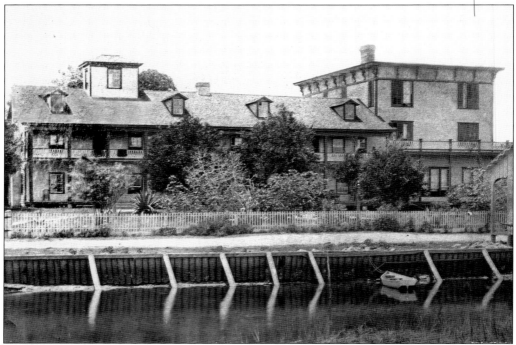

Frank Sams moved to New Smyrna from Oak Hill, where he owned a small hotel. He and Zelia Sheldon were married October 6, 1869. He formed a financial alliance with H. J. Faulkner, clerk of the Volusia County Court. They purchased the Ocean House from Edmund Kirby Lowd in 1883. Sams and Faulkner added a wing to the north side of the Ocean House. Faulkner died, and the Sams purchased Faulkner's interests in the Ocean House from his widow.

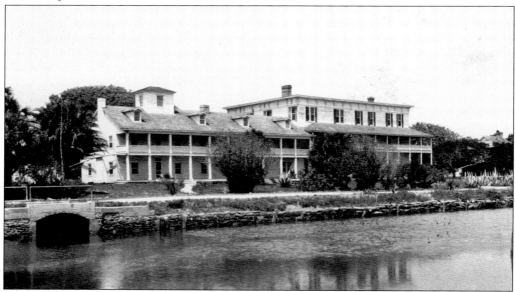

Capt. Frank and Zelia Sheldon Sams succeeded in their operation of the Ocean House. In 1907, Captain Sams had a home built north of Jane Sheldon's cottage and turned most of the management functions over to his son.

The north view of the Ocean House shows one of the rainwater-supplied water tanks that served the hotel. During dry periods, water was pumped up to the tank to augment the supply of water. Josephine Sams, wife of then-proprietor Jack Sams, poses a pointer for the picture. If it were not for structures in the background of family pictures, many building would have never been recorded.

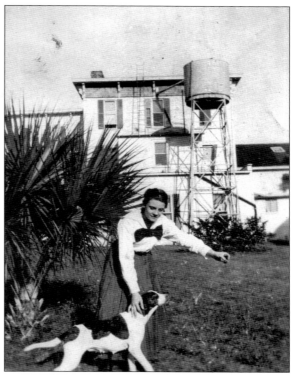

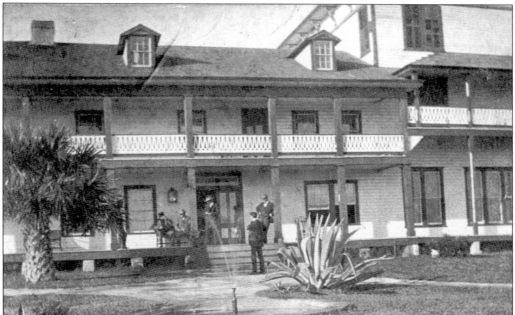

The Ocean House, owned and operated by Capt. Frank Sams and his wife, Zelia Sheldon Sams, was a popular and convenient hotel located at the foot of Canal Street and North Hillsborough Street overlooking the Hillsborough River. Winter brought Northerners down to keep warm in Florida. Sportsmen came for the hunting and fishing.

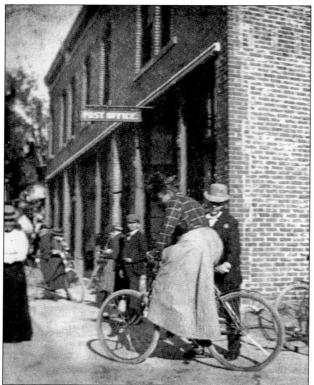

Everyone needs a little help at one time or another, and this gentleman helps the lady with her bicycle. This picture was taken in 1901, before the Maley building was built beside the red-brick Smith building. Maley owned a building built on pilings over the river just south of Berry's drawbridge.

This is a good view of the southern end of the Old Fort Mound from the Ocean House balcony after a large amount of the oyster-shell midden was removed from the south side of the mound. A number of Native American artifacts were recovered from the mound. A coquina wall was structured around the street sides of the mound to protect the midden. The yacht basin is to the right.

The scenic view from the second floor of the Ocean House looks over the creek, marsh, and river. To the right is the slip at the end of Canal Street. The yawl *Volusian* is anchored off the mouth of the slip. At first glance, it looks like the small boat is creating a wake from an outboard motor, but a closer look indicates the man in the middle of the boat is rowing the boat.

This view from the Ocean House balcony overlooks what is now the Municipal Yacht Basin. The *Hell'n Blazes*, Captain Sams's boat, is lying at anchor. The marsh on the right reached across the basin, and entry to the basin was achieved by following the north bank. Jack Sams and Harry Sams dug a ditch through the marsh to make it easier to get out of the basin.

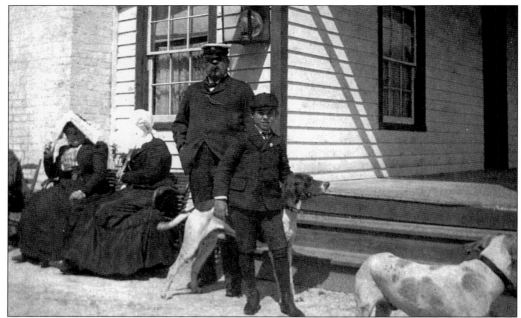

Winter visitors sun themselves on the south side of the Ocean House. Captain Sams's youngest son, Murray (Pat) Sams, restrains the pointer. Murray Sams studied and practiced law. He moved to DeLand. He was elected and reelected state's attorney for the County of Volusia over a period of 20 years before retiring.

Captain Sams strikes a playfully aggressive pose on the south side of the kitchen building to the rear of the Ocean House. The building with a curved roof appears to be a smokehouse, and the building to the right might have been the first schoolhouse in New Smyrna: it is located approximately where the schoolhouse stood.

Edward F. Wilson and his sister, Zelia Wilson, are pictured in front of the Jane Sheldon's cottage just south of the Ocean House. Jane Sheldon retired to this cottage after her second house on the hill was torn down.

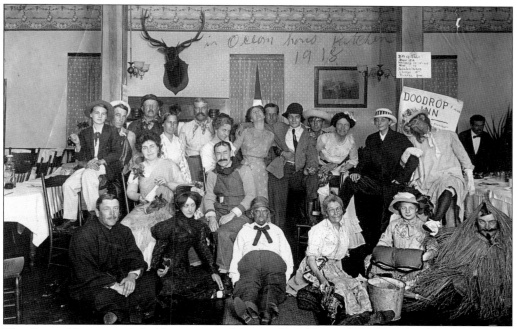

The Ocean House people held parties too. Moving the tables to the side in the dining room and dressing outrageously was not beyond these people. Not having any of the amenities of modern life—they were just getting acquainted with the light bulb—these people were really roughing it, and they did not know it!

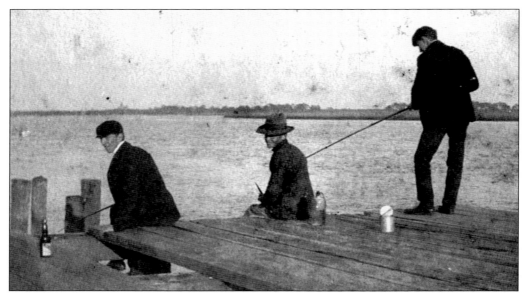

Two Ocean House guests enjoy fishing from the pier at the end of the Canal Street slip. The can may hold fiddler crabs, shrimp, or some other type of bait. The clear jug behind what appears to be a local may contain water or something more stimulating. The bottle on the left has a label, and it may read "orange juice." The fishermen should be careful of the void left by the missing plank.

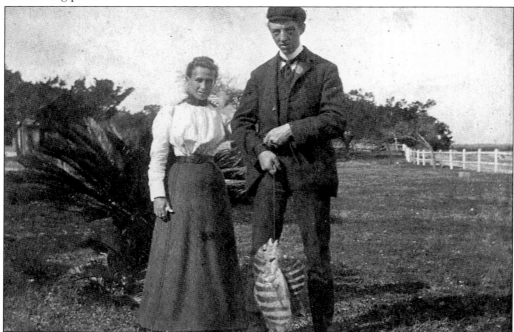

Cora Sams, daughter of Captain Sams, poses with a guest of the hotel and his string of sheepshead. They both appear overdressed for fishing. Perhaps the man is playing the tourist game and wants to show the folks back home what a nice catch of fish he made. In the background is the Old Fort Mound to the north of the Ocean House.

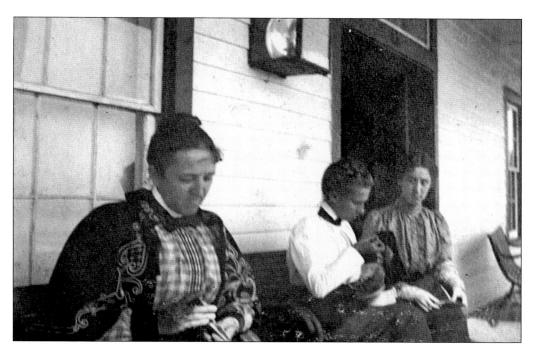

Cora Wilson (center) works on her needlework as the Lowd sisters keep her company. The Lowd sisters' father, Edmund Kirby Lowd, built the first section of the Ocean House. E. K. Lowd and his wife, Victoria Sheldon Lowd, had a home built on the south corner of North Hillsborough Street and Ronnoc Lane. Lowd sold the hotel to Capt. Frank Sams and retired in 1883.

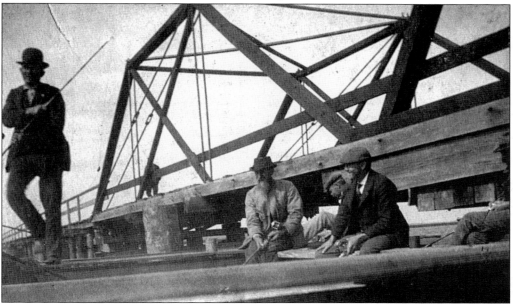

These men fish from the fenders supporting the North Bridge draw span. Generally speaking, the better-dressed are winter tourists. The tourists are fishing for fun. The older gentleman is probably fishing for food. The tourists may be staying at the Ocean House, or they may be staying at the Barber House.

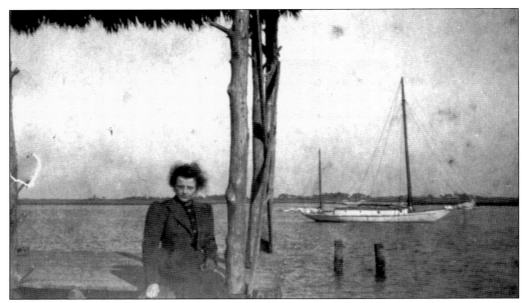

A tourist poses for her picture with the yawl *Volusian* at anchor behind her. New Smyrna is located near the Mosquito Inlet. The name of the Mosquito Inlet was changed to Ponce de Leon Inlet in 1926. The name of the river to the north of the inlet was Halifax in honor of Lord Halifax. The river to the south was named after Lord Hillsborough, but its name was changed to Indian River North in 1901.

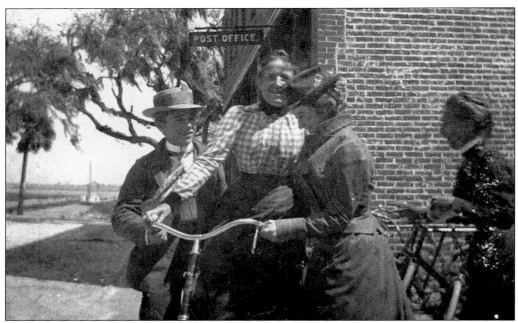

Canal Street is crowded as the locals arrive to pick up their mail and stop at Ritzy's for a milkshake or scoop of ice cream before going on their way. The boat *Hell'n Blazes* is lying beside the bank at the foot of the street. Years later, the Captain's Quarters would occupy the north side of the slip to the left of the boat.

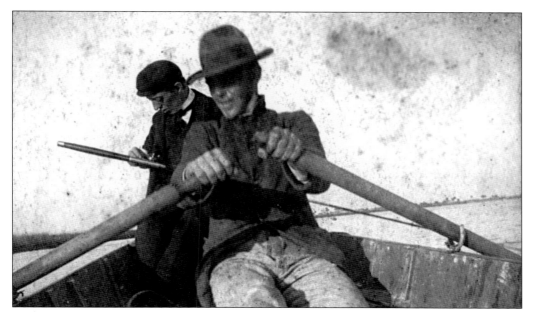

Looking for better fishing grounds, the tourist hires a fishing guide to row him to a better location. The reel seems to engage the interest of the tourist, as he attempts to unsnarl a backlash. Bottom fishing was common in the area. There were plenty of drum, sailor's choice, sheepshead, red snapper, and catfish.

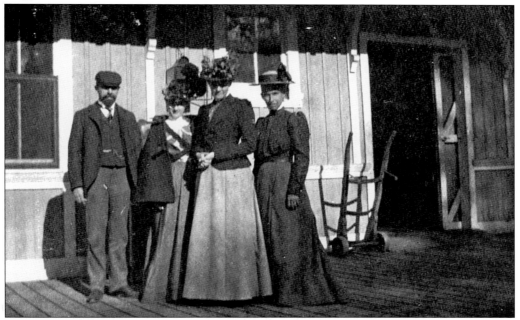

Members of the Ocean House staff met the guests of the hotel at the railroad station when they arrived and took them to the station when they were departing. Cornelia Sams, daughter of Captain Sams of the Ocean House, is on the right in the picture above. The others are not identified. The people are at the first FEC station in New Smyrna, located on the east side of the north/south tracks.

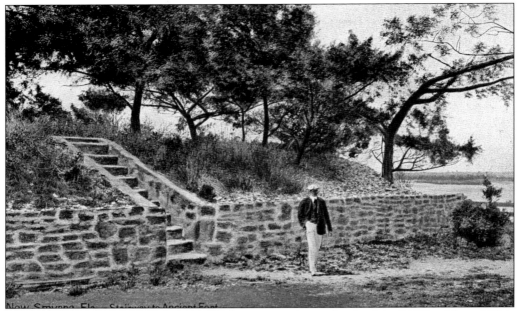

This well-dressed gentleman stands beside the steps on the south side of the Old Fort Mound. This coquina wall was built before the WPA and was used to preserve the integrity of the south side of the mound and as steps to encourage tourist visits. One of the owner/leasers of the property tried to promote the Old Fort as an attraction.

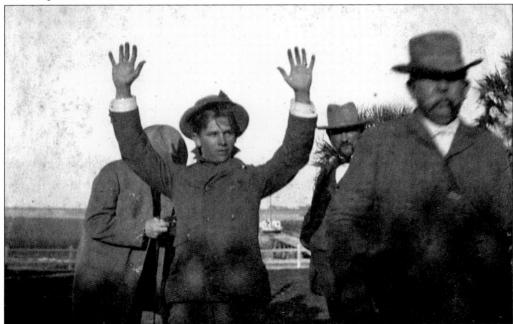

Enacting a parody, the hotel's guests pretend to hold up the proprietor, Capt. F. W. Sams. Captain Sams took the ribbing well and was happy to have them as paying guests. Perhaps extreme by some standards, this type of playfulness was reflective of the casual and relaxed attitude of the community at that time and is not uncommon in the community of New Smyrna today.

Three

SIGHTS AS SCENES

Some photographs of public transportation before the railroads are included. Tourist travel before the railroads was usually by boat down the coast or up the St. Johns River. Hunters could shoot any number of varieties of animals, including black bears, deer, feral pigs, and many species of birds. Of course there were also many alligators to shoot. Fishermen were in their heyday as fish were large an plentiful. There are some photographs of naval ordinance delivered into the community and a sketch of what that ordinance could and did do. There is no picture of Louise, the first Mrs. Connor, the one that should receive credit for having the Connor Free Library built. Jeanette Thurber Connor, the second wife of Washington E. Connor, was a writer and historian is pictured. Jeanette Thurber Connor was instrumental in reviving the Florida Historical Society, and she really believed the sugar mill was a Spanish mission. The navy crash boats were here during World War II and rescued crash survivors and recovered some that did not survive from the ocean.

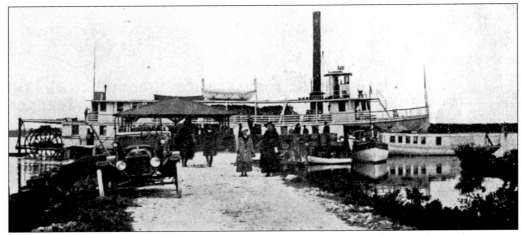

A sternwheeler is docked at the end of the causeway at the foot of Canal Street. Several passenger vessels plied the waterways along the east coast of Florida. Daniel Perkins Smith Jr. first came to New Smyrna as a ticket agent for a steamship line. Smith married Caroline (Carrie) Lowd. Later he was elected tax collector.

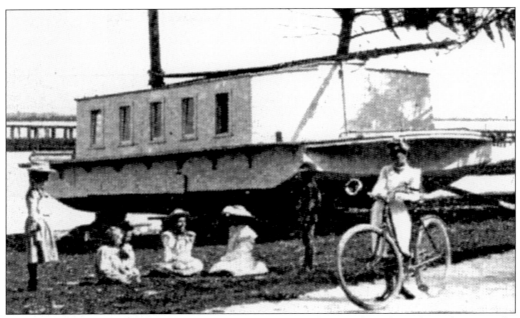

The *Hell'n Blazes* is high and dry and furnishes nice a background for the girls as they pose for another picture taken by A. E. Dumble. Dumble had these children pose in various places around town, and by doing so, he preserved scenes reflecting the community of years past. Much of the ambiance reflected in these picture remains today.

Looking north from the Shyrock pier, this boy in the foreground has to be a Yankee—no locals would dress in that fashion. The man may be accompanying the boy to keep a watch over him should he endanger himself by falling into the water, but maybe not.

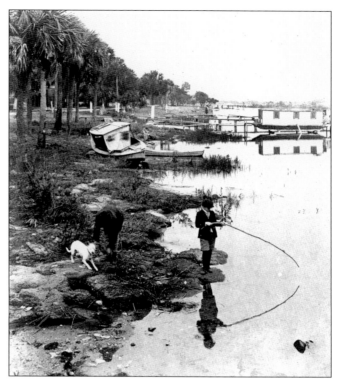

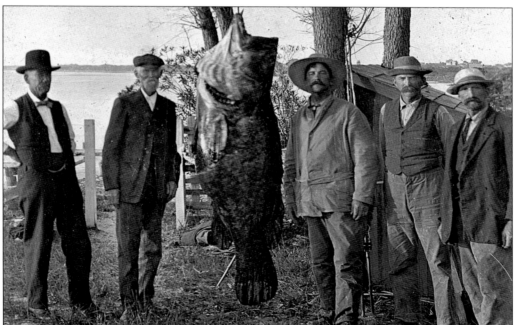

Daniel Perkins Smith Jr. stands on the left side of the picture. Guide T. J. Stewart stands to the right of the large grouper. The others are not identified. The location is north of the North Bridge, and the viewer is looking to the north.

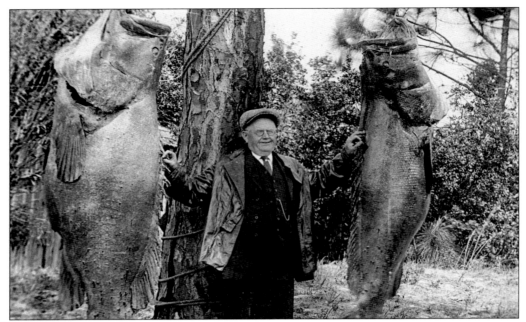

Standing between two jewfish (*promicrops itaiara*) that are as large or larger than he is, Mr. Soloman looks very happy. It is unknown if Soloman caught these fish himself. Occasionally people would wander by, and a photographer would offer to take a picture of them with the fish for a fee; perhaps Mr. Soloman wandered by.

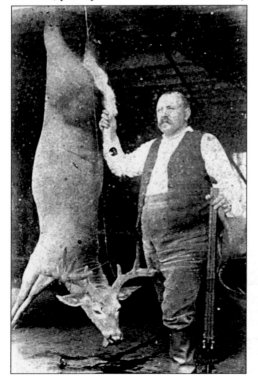

Washington Everett Connor stands beside his prey. Connor was an investment banker that visited New Smyrna in the late 1880s. He enjoyed the visit so much he returned, built a home, and invested in the community. Connor stayed at the Ocean House during his early visits. Capt. Frank Sams said he was a pretty good poker player and a tolerable hunter.

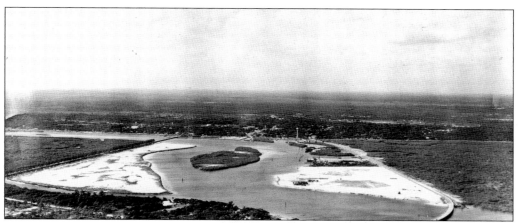

This aerial photograph taken in the early 1950s shows the newly filled Bouchelle Island development on the left and the spoil island in the center. The marshland that became Venezia is on the right of the North Causeway, and what became Buena Vista subdivision sparkles brightly in the right foreground. The Australian pine-lined South Causeway and the North Causeway embrace urban growth potentials.

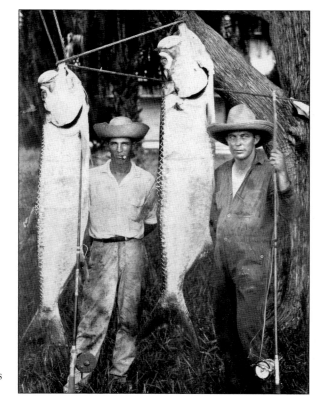

Francis Wilson and Arnold Dilzer (on the right) show their tarpon. Tarpon are considered a game fish and are plentiful in the estuary in July and August, when they come inside of the inlet to spawn. They make quite a show when they leap out of the water during the chase. Locally the tarpon is considered a game fish and not eaten as a rule. In other areas of the world, the tarpon is considered a food source.

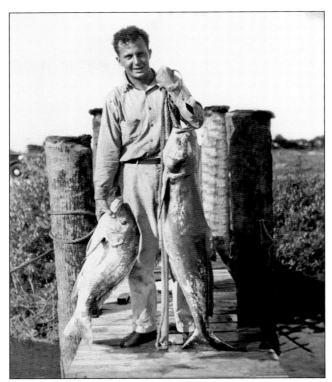

Standing on a dock in the bay, John D. Sheldon III shows his catch: on the right a cobia (*rachycentron canadus*) and on the left a red snapper (*lutainus blackforda*). Where he caught these remains his secret.

The fisherman is looking to his seine net to determine the damage done by the sawfish he trapped. This was an unusual catch, as sawfish do not frequent the estuary. When fish enter a creek, a seine can be drawn across a creek to trap them. Sawfish are more trouble than they are worth when caught in a seine, because they destroy most of the net.

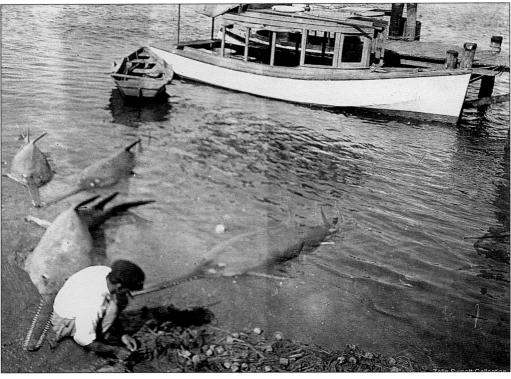

Zelia Sweett Collection

This large grouper was caught with the equipment Dr. B. F. Fox is holding: a length of three-quarter-inch line separated from a large hook by a chain. The fish feed near underwater rocks, bridge pilings, and accumulations of debris, where they lie in wait for their prey.

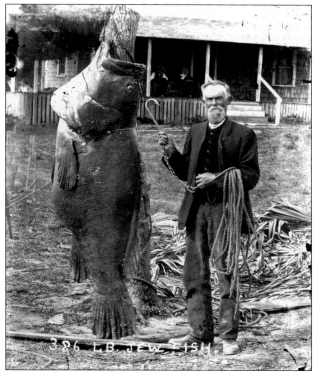

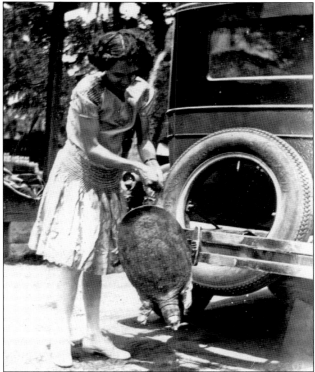

The lady holds a snapping turtle by the tale. The turtle holds a stick in his mouth and is not about to let go. Did she let go and drop the turtle and run? Did she drop the turtle in a box to save it for the cook? Did she drop the turtle in the river? I guess we will never know what happened to the turtle.

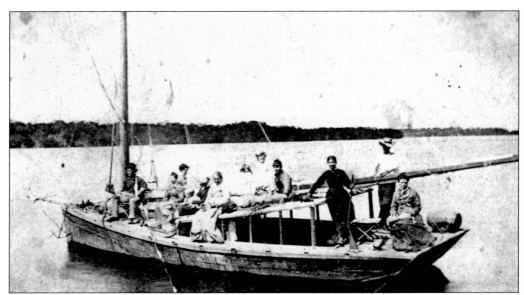

Zelia Sheldon Sams stands with her trusty weapon while she waits for the rest of the party before getting underway for Mosquito Lagoon. Jane Murray Sheldon holds one of her grandchildren on her lap; her sister-in-law Susannah Lourcey Murray faces the camera. Zelia appears to be in her 20s in this picture; if so, the time period is in the 1870s.

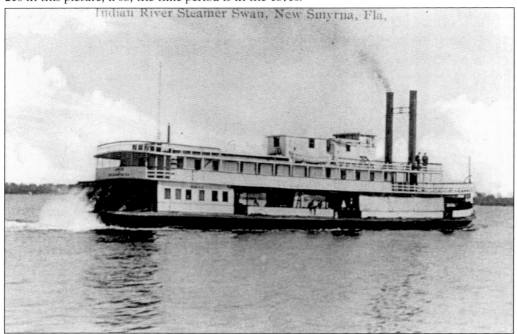

The paddle-wheel steamer *Swan* leaves New Smyrna heading for Eldora and points south. Daniel Perkins Smith Jr. came to New Smyrna as a ticket agent for one of the steamship lines servicing the area. He met and married Carrie Lowd. He later was elected county tax collector and served 40 years in the job. His daughter, Cornelia Smith Paul, was subsequently elected to the same position, and she served for 40 years also.

The gaff-rigged sloop *Folly* sails near shore as she prepares to tack to starboard.

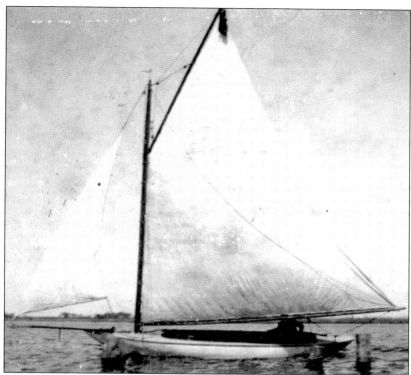

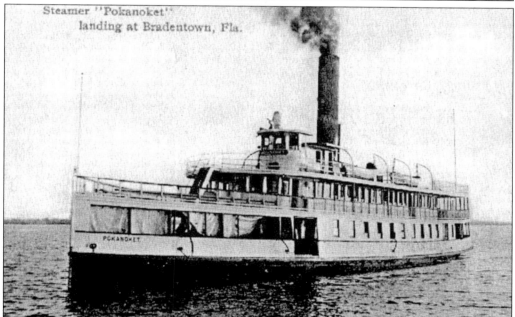

The small coastal passenger ship *Pokanoket* approaches the pier to deliver or to take on board goods and passengers. Freight items were transported on the main deck, and passengers were quartered on the upper deck. Passage was safe, slow, and deliberate. This was one of several vessels built along the same lines that served inshore around the coast of Florida.

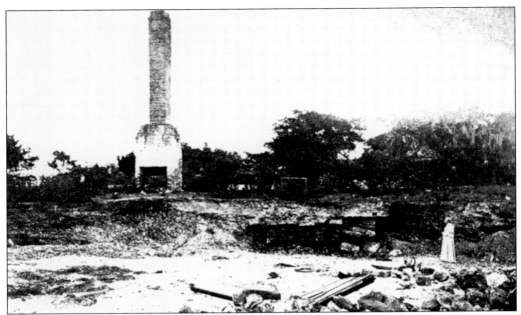

Which of the ruins is Jane Sheldon surveying? The building destroyed by federal gunboat cannons? The building built after the Civil War? Both were built on top of the Old Fort ruins. In the foreground are some objects that appear to be columns; there were no columns in the second building.

This is a sketch of the cannonading of the Sheldon house in 1863. Poetic license and imagination are presumably at work in this rendering. The inventory of John Sheldon's estate indicates there were a barn/stable, kitchen building, slave house, boathouse, and small dwelling house on the property. Evidence of the kitchen building was discovered on the northwest corner outside of the Old Fort ruins/foundation.

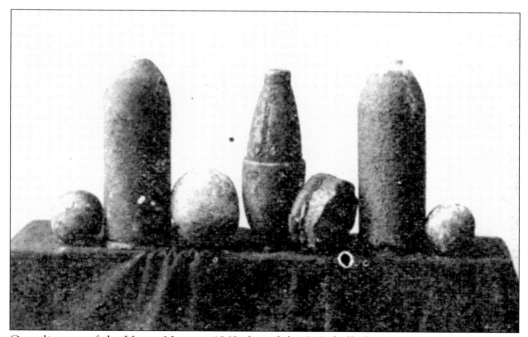

No. _3833_ **Confederate States of America,**

Depositary's Office,

Tallahasee, Fla., 31st Nov , *1864.*

THIS WILL CERTIFY, That _Jane Shelton_

has paid in at this office _Four Hundred_

~~~~~~~~~~~~~~~~~~~~~~~~~~~~ Dollars,

for which amount Registered Bonds, of the Confederate States of America, bearing interest from this date, at the rate of four per cent. per annum, will be issued to him, under the "act to reduce the currency," approved February 17, 1864, upon the surrender of this Certificate at this office.

$400

_____ Depositary.

FOUR PER CENT. PER ANNUM.

The widow Jane Sheldon supported the cause and invested $400 in the Confederate Sates of America toward the end of the Civil War. Her son died in service, her husband died in the Bahamas, and her home was destroyed by Federal cannon fire, yet she remained stoic and faithful to the end.

Compliments of the Union Navy in 1863: few of the 280 shells fired into New Smyrna were explosive. These are seven of the types of projectiles found after the cannonading. The Sheldon home/hotel, Ora Carpenter's Tavern, and the stone wharf were destroyed. Carpenter moved to Enterprise and sold his property to Edmund Kirby Lowd. There were no reported casualties.

"Let Ball and Grapeshot fly, Trust in God and Davis, but keep your powder dry!" George Sheldon served in a Florida regiment attached to the Army of Northern Virginia. He fought in the battles of Manassas (Bull Run) and others before contracting pneumonia. He died in a hospital in Richmond, Virginia. The above poem was copied from the letterhead of one of George Sheldon's letters.

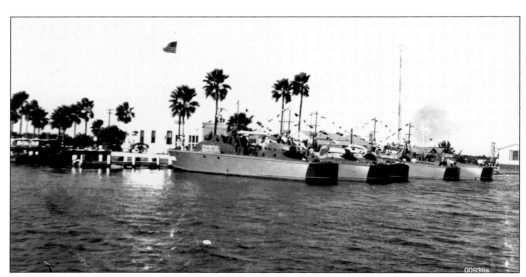

Navy crash boats docked at the Anglers Yacht Club during World War II. The crash boats went to sea when the flyers were training. Should one of the planes crash into the water, hopefully the boats would pick up the pilot. Later the boats moved over to the municipal docks, and the Coast Guard took over the Anglers Club for the duration.

Four

RANDOMLY ABOUT

Floods and fires raise havoc in a community when they occur. They community works through the damage done and a serious event tends to bring communities together in order to work their way out of the trouble created. The railroad came to town in a serious way in the 1920s, and it was the single most important economic boost the community ever had. The Depression hit New Smyrna as hard as anywhere, and there was almost no flow of cash. As hard as times were, the tramps could still get a meal at many of the homes on their way through town. The WPA provided employment as did the CCC, and a lot of men found their way into the armed services. The beginning of World War II started the economic ball rolling, and slowly New Smyrna worked its way out of poverty. Perhaps the best thing about it was most of the young did not know how really poor the community was at that time. The railroad strike in the 1960s ended the railroad era in New Smyrna. The space program at Cape Canaveral took up a lot of slack in the labor force, and things moved on.

Jeannette Thurber Connor, Washington Connor's second wife, earned credit for revitalizing the Florida Historical Society through her research, writings, and actions. Mrs. Connor was firmly convinced that the sugar mill ruin was a Spanish mission. Her firmness in her belief and her research gained other adherents to her premise. Cruger and dePeyster built the sugar mill in the back of town in the 1830s. After the Seminoles destroyed the mill in 1835 and payments were not made, the mortgage was foreclosed by a Mr. Kimble of New York.

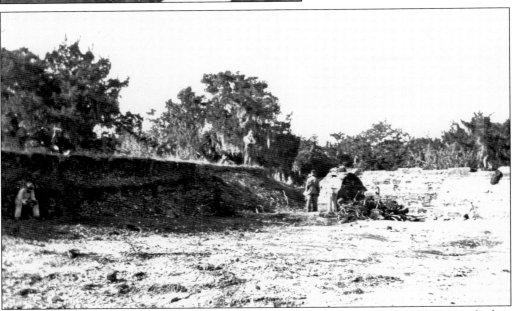

The WPA began work restoring the ruins known as Turnbull's Ruins or the Old Fort in the late 1930s. There were no plans to refer to in this venture because no one knew what the ruins were or had any idea if there was anything to restore. They built up the ruins, built a coquina wall around the mound, and left. There is a lot of speculation about what the ruins are, and the farther away the visitors come from, the wilder the speculation.

This candelabra was pieced together from the fragments of three such found on the Sugar Mill grounds. The Connors owned the Sugar Mill grounds. The candelabra supported the belief the sugar mill was a Spanish mission. Alas, some wise guy told the believers the candelabra was of a later time period than Spanish missions; no one argued with the guy.

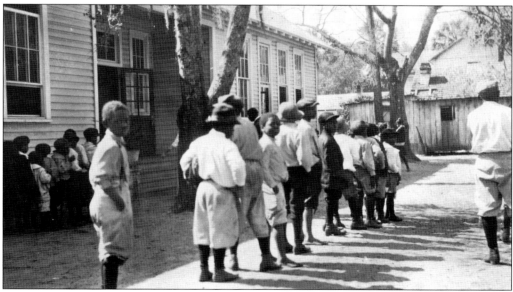

Students standing in line are nothing new at school. This might be the first day of the school year for the Chisholm school, as the students look pretty sharp. The school was located on Julia Street in the block east of Myrtle Avenue.

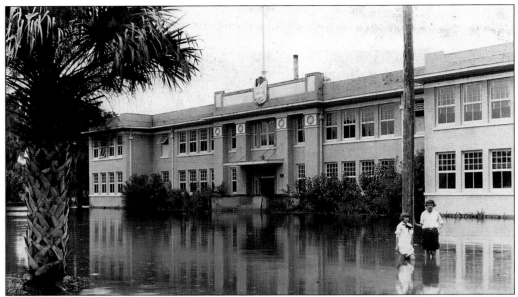

The Faulkner Street School, the fourth school and the third building built as a school in New Smyrna, was completed in 1916. It housed 1st through 12th grades. The 1924 flood flooded the grounds and the basement of the school. Some of the children and adults went swimming in the basement. The school bell on the roof of this building received more than its share of attention from students and mischievous adults over the years. Blanch Galbreath Clark is the smaller of the two girls pictured.

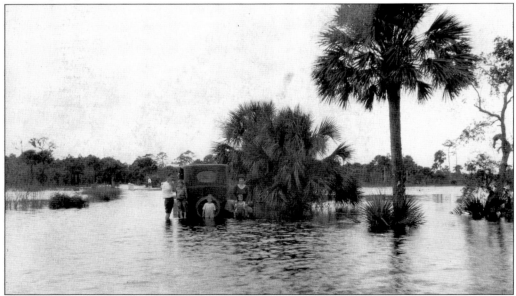

It is difficult to see the man in the background standing on the Turnbull Creek Bridge on Pioneer Trail. The water is at the top of the bridge, and the area is flooded as the result of the record rainfall. The elevation of the bridge at that time is unknown, and it is difficult to relate how high the bridge is today in comparison. It is fair to say the area would be flooded again if the water were that high.

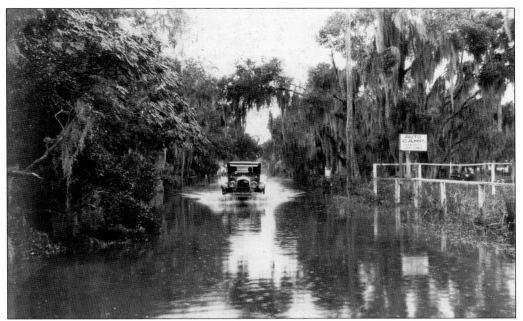

Old Mission Road was flooded during and after the rains of 1924. It took weeks for the water to evaporate or sink into the ground in most of the low places. The drainage was limited, and the almost all of Turnbull canals had long been filled in, diverted, or were overgrown with vegetation.

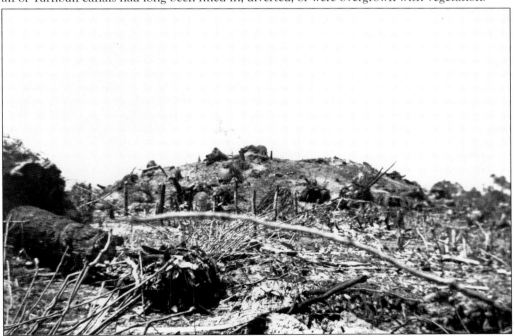

This midden became part of an airfield. The land was cleared in order to plant crops, and the midden was removed in the clearing process. The agricultural venture was not successful, and one of the reasons may have been because the coquina is so close to the surface in that area. Later a nine-hole golf course and a grass-surfaced landing field were developed at the site.

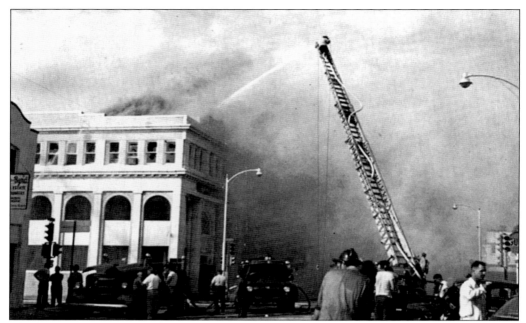

The bank fire in New Smyrna on September 22 and 23, 1954, was a two-day affair. The fire was started by spontaneous combustion in the collector bag of a floor sander that was not emptied. The smoldering sawdust burned through the bag and fell to the floor, making a circular hole as it burned through the floor. The fire worked it way under the second-story floor and made it way throughout the building before it was discovered early in the morning of the next day.

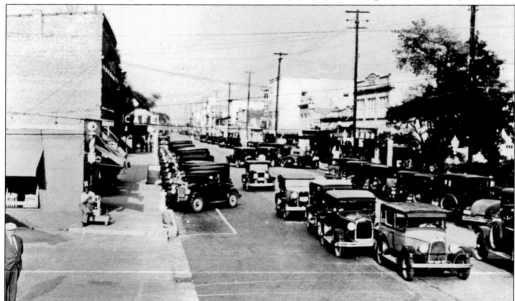

This view looks east on Canal Street in the 1920s. Signs at the traffic light at the intersection indicate an east turn to follow U.S. Highway 1 to the next traffic light. A right turn onto Magnolia Street leads south toward the tourist mecca of Miami. Even today, tourists traveling south will occasionally stop and ask, "Are we in Florida yet?"

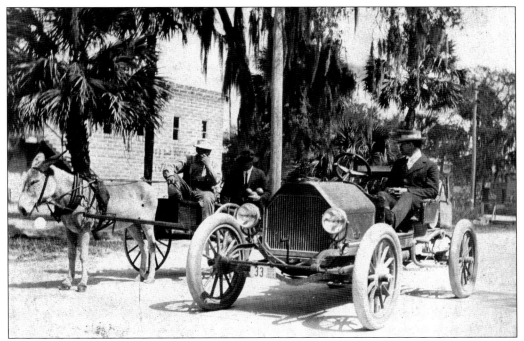

A farmer with his mule-drawn cart brings his produce to market in downtown New Smyrna. The chauffeur waits as a seasonal resident, Mr. George H. Werfelman, shops. In the background is Newell's Livery.

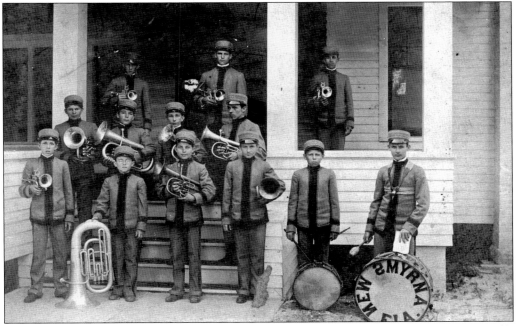

The boys of the marching band stand for their picture. It was rumored their enthusiasm initially outweighed their ability, but their skill improved with dedication and practice. Kirby Chilton is the only identified member and is standing by the small snare drum.

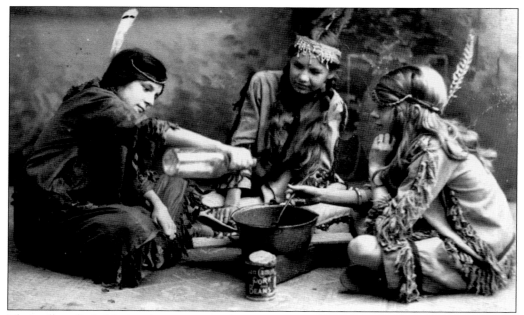

These three little Native Americans are brewing a mess. From left to right, Edna Greer, Zelia Wilson (Sweett), and Verna Jones (Botz) dressed as Native Americans when they were Campfire Girls. The Campfire Girls organization preceded the Girl Scouts.

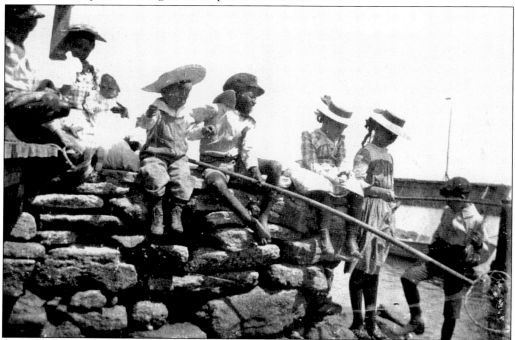

It takes a while to attract a crowd in a small town. The guy with the fishing pole may be fishing in very shallow water, but the crowd does not seem to care, as they appear enthralled. This may very well be a posed picture, as those hats appear in other pictures that were posed by A. E. Dumble.

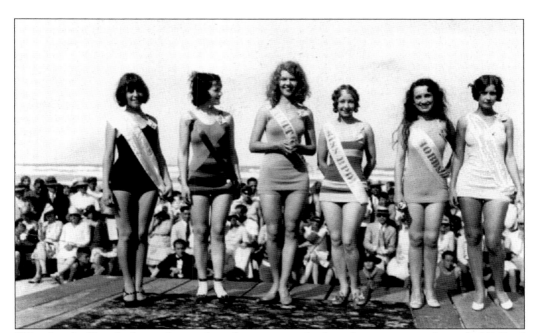

What kind of beach do you have when there is not a bathing beauty contest being held? Opal Eamer and Catherine McDonald are in the picture, but it is not known which ones they are. The others remain nameless.

Washington Everett Connor was not all work and no play, as he hosted an occasional bash at the Indian River Ranch. Later the ranch was a school for young gentlemen of means. There were classes, teachers, and of course horses to ride. The Little Theatre began its run in a barn on the property after World War II. Hannah Dewiler Bonnet donated land on Third Avenue for a new theater.

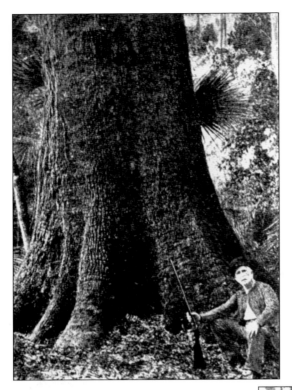

Samuel Andrew Galbreath poses at the foot of the largest live oak tree in Turnbull Hammock. The tree measured 10 feet in diameter and 33 feet in circumference and was estimated to be over 100 feet tall. The tree died after being struck by lightning.

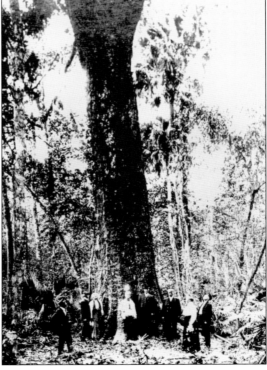

Here is another perspective of the tallest live oak tree in the forest. The picture shows about half the height of the tree. Among the group of people at the base of the tree is Mr. Fred Van de Sande, ubiquitous local photograph and the man responsible for many of the pictures in this collection.

The storied, four-headed palm tree grew in Belle Murray's yard on North Orange Street. Tourists stopped to take pictures of the tree when North Orange Street was U.S. Highway 1. Belle Murray gained her privacy when U.S. Highway 1 was moved to the west. Winds from Hurricane Donna took the tree down in 1960.

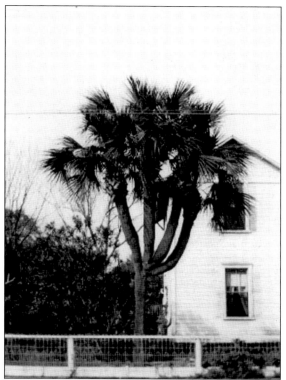

This slip was located at the end of Canal Street in the early 1950s. Shrimp boats and fishing boats were docked in this slip and at Feger's, Damgaard's, and Ryan's Docks along the Indian River North. The shrimping and commercial fishing catches fell substantially after the 1930s and late 1940s, and the number of fishing boats diminished accordingly.

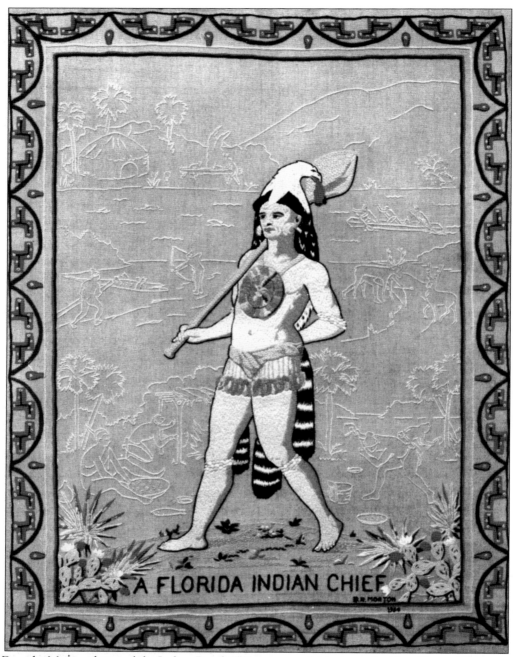

A FLORIDA INDIAN CHIEF

Dorothy Morton designed the Indian Panel 1565 tapestry, which was embroidered by needlewomen of the WPA Women's Work Center. It is striking when viewed in color at the New Smyrna Museum of History. Turtle Mound is depicted in the background, as are native huts, hunters, fishermen, food preparation, agriculture, canoeing, and disguises to fool the deer.

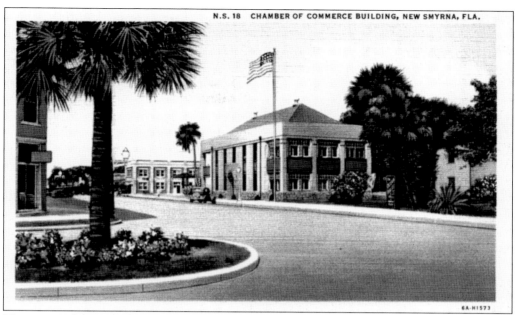

This postcard from the late 1930s shows the WPA-built chamber of commerce as well as the end of Canal Street at the river. The palmetto tree in the circle was used as a turning point when locals cruised the street in their cars. The building on the left housed a bank at one time and was torn down soon after this picture was taken.

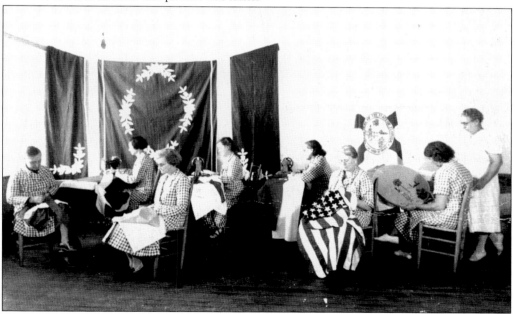

On October 24, 1939, the *New Smyrna News* reported, "Work of the New Smyrna Beach WPA Sewing Room received strong commendations at the assembly room of the new courthouse in Orlando yesterday." During the business session, Mrs. Southworth, State of Florida supervisor, complimented Mrs. Wilson and her workers on the outstanding work produced by the New Smyrna Beach Room.

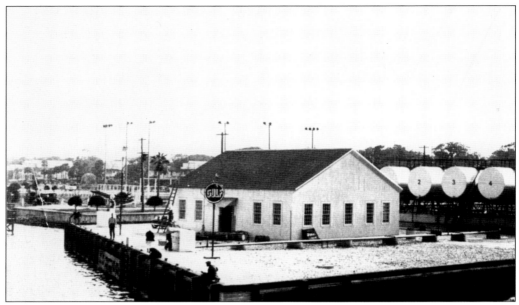

The Standard Oil Company controlled the railroad. Gulf Oil built on the waterways and shipped their fuels by barge. The property was sold by the Gulf Oil Corporation, and the Captain's Quarters was built on the land. Charles H. Sams managed the Gulf Oil Bulk Plant at the foot of Canal Street for over 40 years.

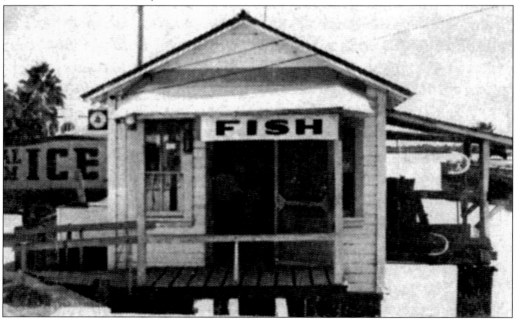

William (Bill) Lourcey owned and managed this small fish house at the foot of Canal Street. Lourcey was present as a child when the Sheldon house on the hill (Old Fort Mound) was cannonaded and destroyed by the USS *Beauregard* in 1863. His stories about the incident were legendary, and while enhanced from what he was told by his mother and others present at the time, the stories were remarkable in their vividness of presentation.

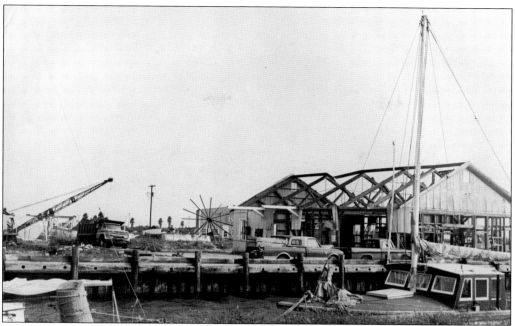

Here contractors are removing the Gulf Oil Bulk Plant to make way for the Captain's Quarters building. The fishing boat in the foreground made regular trips of a week or two to sea. The sail stabilized the boat when hoisted and kept the boat from jumping about as much. They stored ice and could only stay out as long as there was enough ice to keep the fish from spoiling.

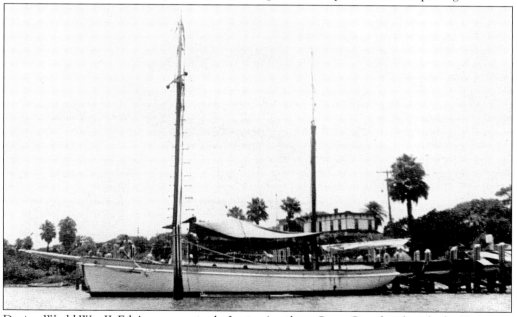

During World War II, Ed Ayers organized a Junior Auxiliary Coast Guard and made the *Hurricane* the base and training ship. Philip Colborn was first mate, Larry Sweett second mate, and Jim James, Ward Tuten, Nial Pace, Hibbard Robinson, Bill Gillespie, Robert Graham, and Robert Guest made up the crew.

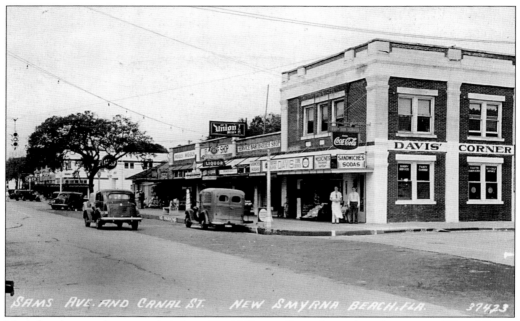

Many locals started out as soda jerks at Davis' Corner Store, located on the corner of Canal Street and Sams Avenue. The building was built for use as a bank. The ice shaver was in the concrete vault. The Bank of New Smyrna was across the street, and the post office was down Sams Avenue. Donald Curry (left) and Burt Calhoun stand in front of the store.

The *Florida Star* began publication in 1877 in New Smyrna and is still being published as the *Titusville Star Advocate*. The *Breeze* was first published in 1887 with John Detwiler as the editor. The *Breeze* newspaper was a victim of the Depression years and discontinued publication in the early 1930s. The *New Smyrna News* began publication in 1913 and was published by Harry Rood.

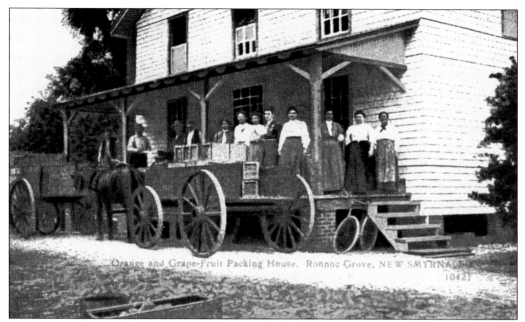

The Connor Grove packinghouse was located across the railroad at the edge of the groves off what became Ronnoc Lane. The citrus fruit was picked from the trees when ripe, boxed, and taken to the packinghouse, where it was cleaned, sorted, and packed for shipping by the railroad to market.

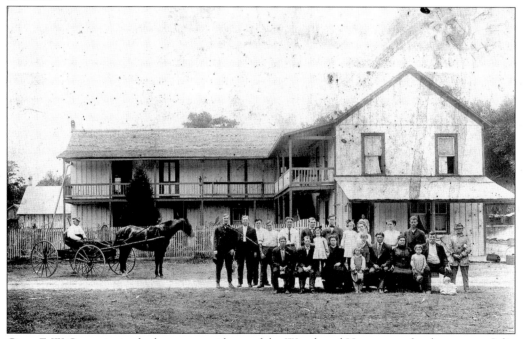

Capt. F. W. Sams sits in the buggy as residents of the Woodward House pose for the camera. Julia Woodward observes from the doorway. This was a well-run boardinghouse popular with railroaders. The house was full during the winter months, when the railroad was most active.

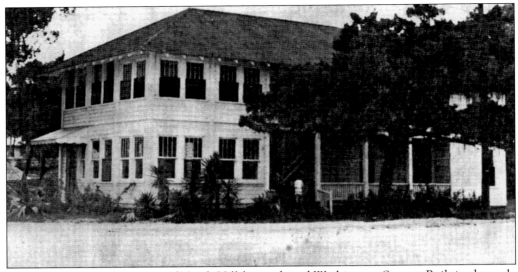

This house was on the corner of North Hillsborough and Washington Streets. Built in the early 1900s, the building housed many different small businesses. Lena Marshall owned the property for many years. "Aunt" Judy Moody had a soda-pop shop in the rear of the building. She was followed in business by a German who ran a repair shop. Upstairs was an apartment. Among the last tenants were Mrs. H. S. James and her daughter, Meriam Hughes, who operated a gift shop.

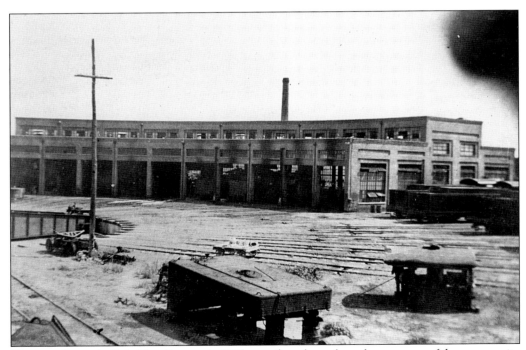

The roundhouse built in New Smyrna in 1925 contributed greatly to the economy of the community and the FEC by providing a place to service multiple locomotives and providing a place for employment. A turntable was built in front of the building to select the wing to run the locomotive into. Rails were laid to each wing for the locomotives to enter and leave the facility.

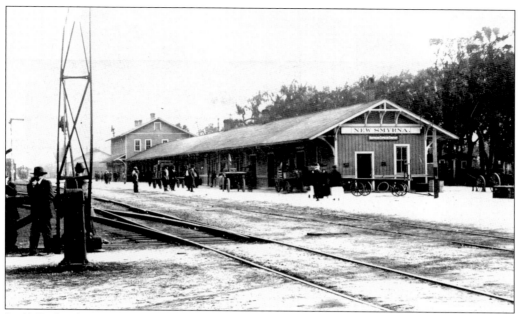

In 1917, the depot included the Railway Express Shipping Service that occupied the one-story section. The covered passenger waiting area separates the two-story section to the left. The ground floor housed the Railroad Restaurant. Functional for passengers and townspeople during the day, at night it became a social haven for the late-night roisters and revelers. Located upstairs was the dispatcher's office.

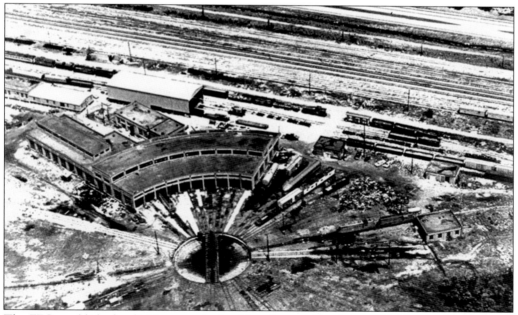

The FEC established a division terminal at New Smyrna Beach in 1925. The establishment of the northern division terminal created a major source of employment for the community. During World War II, the engines went as far north as Washington, D.C., as well as other places far removed from the FEC-owned roadbeds and routes.

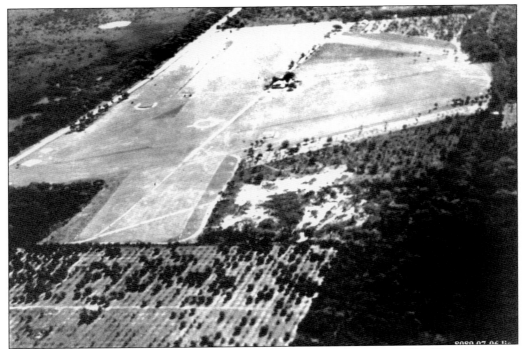

This aerial view of the New Smyrna Municipal Airport was taken about 1939. The airport was basically a flat open space that also served as a nine-hole golf course. The clubhouse in the middle of the picture later became the control tower when the navy took over, and the runways were built to serve as an auxiliary airfield during World War II.

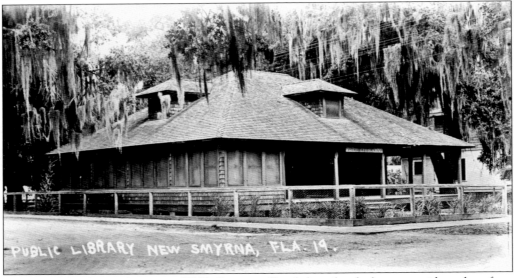

Inspired by his first wife, Louise, W. E. Connor offered the sale of a lot to provide a place for a library building, using the money gained to build a library building. Connor paid the operating expenses of the free library. He gave the building to the city in 1925. Strings were attached, and when the Men's Garden Club used the building, a collection of books had to be maintained as a library.

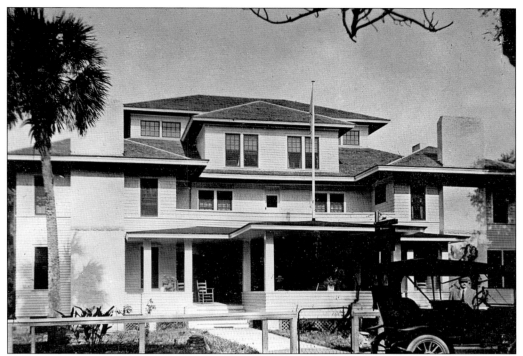

The Alba Court Inn is pictured soon after it was built in 1907. The building survived for many years but is slowly facing destruction by time and termites. Even in good times, the inn owners had to struggle to make the building economically productive. Finally, when the market was there to support the inn, the old-fashioned inn was out of the market.

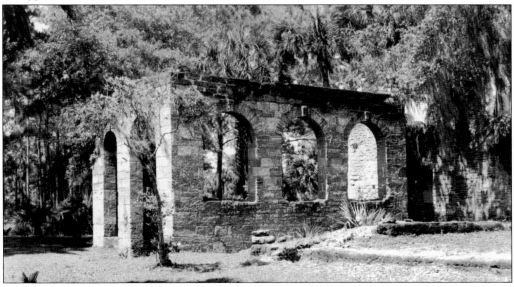

The sugar mill, destroyed at the outbreak of the Second Seminole War in December 1835, is one of the really tranquil and beautiful places to visit in New Smyrna Beach. Cruger and dePeyster built the mill in 1830, and it was destroyed in 1835. This photograph was taken by Fred C. Van de Sande.

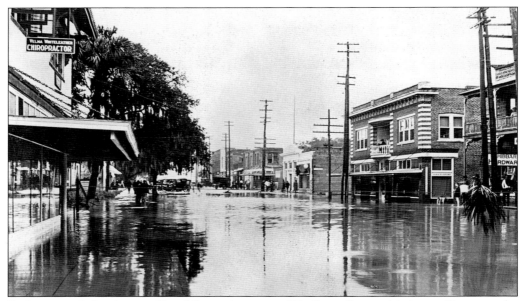

Facing toward the river on Canal Street just west of Faulkner Street, this image illustrates the extensive flooding. The white building on the right is the bank building at the corner of Canal and Magnolia Street before the third floor was added. Rainwater drained into the storm drains and into the canal beneath the sidewalk on the left. Water flowed freely into the open canal west of Myrtle Avenue, which was not covered by the sidewalk.

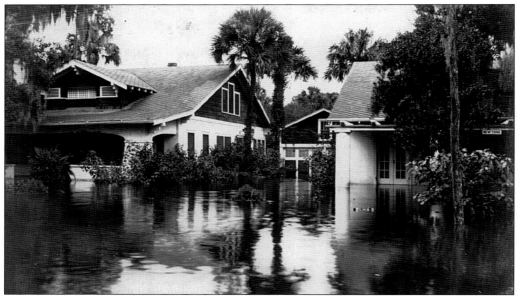

This home on Faulkner Street was one of the many flooded by the 23-plus inches of rain that fell upon the community during a 24-hour period in 1924. Nordman's rain gage attested to this at the time. There are those that believed Mr. A. B. Nordman was remiss by not emptying the gage until after some 30 hours had elapsed. It was a severe northeaster, and it was raining hard. In any event, as the result of this official reading, the town held the record for rainfall in 24 hours for the United States until Cedar Key recorded a greater amount in the 1950s.

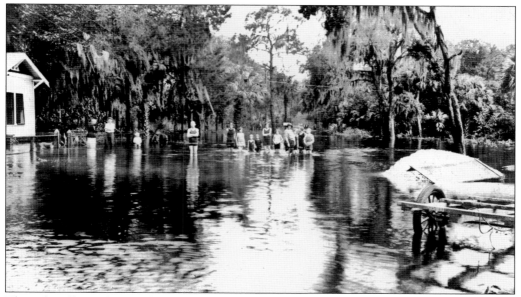

The sidewalk on the north side of Canal Street covered the canal from the river to Myrtle Avenue. The sidewalk stopped on the west side of Myrtle Avenue. Other old canals drained into the Canal Street Canal and contributed greatly to the flooding of the area. It took several days for the flood water to drain after the wind and rain subsided. Some low spots retained the floodwaters for months.

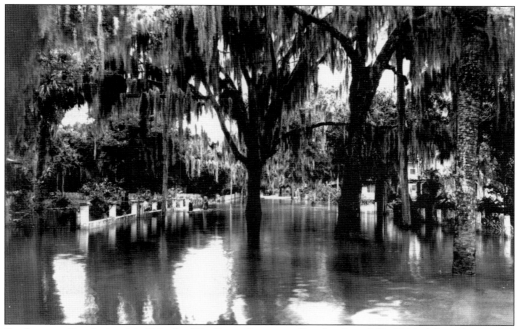

Fresh water floods the third block of Faulkner Street on October 9 and 10, 1924. After a hurricane passed along the coast, a northeaster dropped 23.22 inches of rain upon New Smyrna in a 24-hour period. The official amount was reported by A. B. Nordman as taken from the rain gauge in his grove north of the airport.

Edward F. Wilson, the son of Lawrence Edward Wilson and Cornelia Sams Wilson, was born in New Smyrna, educated locally at St. Leo's Academy, and studied at the University of Florida. He was in the army as a pilot at the end of World War II. He and his brother, Francis Edward Wilson, were real-estate developers and builders during the early 1920s. In 1924, Ed Wilson built an office building and post office that today houses the New Smyrna Museum of History.

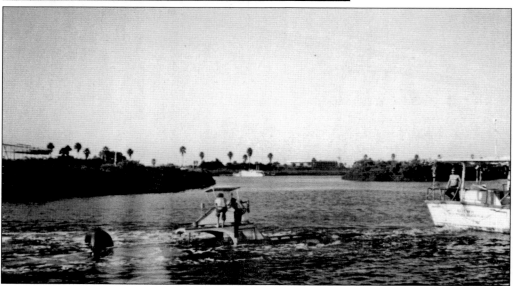

The *Optimist* is towed away from the municipal docks after sinking for the 10th time. The owner sold the boat on credit, and the new owner took it to Titusville. The new owner did not pay on time, and an attorney took over to collect. He procured two slow payments, and when he did not receive another payment, he told the new owner to pay up or bring the boat back. The new owner brought the boat, back canceling the note. The boat sank the next day, and the next day, and the next day!

These men had to use a hoist to raise this large manta ray out of the water. Manta rays are the largest of the rays, ranging over 20 feet across. Harmless to man unless he should fall on you after leaping out of the water, they do not have the stinger tail the smaller rays have. Ocean fishermen troll near the manta rays because fish feed near them.

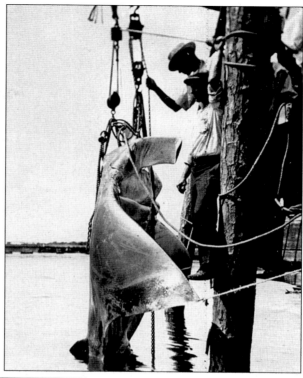

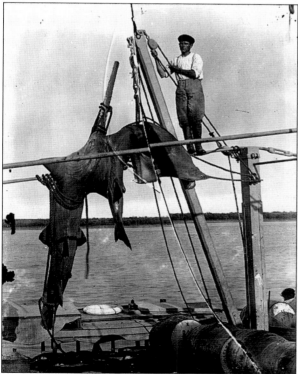

The Florida small-mouth swordfish is on the threatened list as the species slowly disappears. Whether this is a small-mouth swordfish or not is unclear. These guys died when they swam up a small creek, and a seine was stretched across the creek. The swordfish is a close relative of the shark and can be very dangerous when that sword is swished about.

During the 1920s and into the 1950s, southbound U.S. Highway 1 in New Smyrna was one lane from the northern city limits past the combination nine-hole golf course and grass-surfaced airport until the New Smyrna sign. The welcome sign was located near where the Regions Bank is today. A median separated the traffic lanes. The median ended at Ronnoc Lane. In town, the road was called North Orange Street

An aerial view of the Live Oak Street School to the northeast shows the second South Bridge and Bouchelle Island before the growth factor got serious. The school building was removed, leaving the gymnasium, which has become a municipal building. The county built a library on the back portion of the lot after closing the through street.

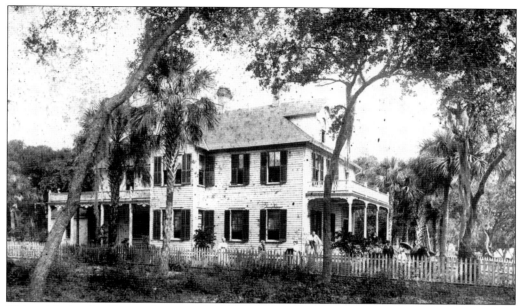

This might be the Connor house on North Hillsboro Street at Ronnoc Lane. People are spread out about the premises prepared for the picture. There is a horse with a man in what appears to be a uniform and a lady with a parasol in back of him. The man on the porch and the people in front are posed for the picture. It is a beautiful house and one of the better houses in the community in the early 1900s.

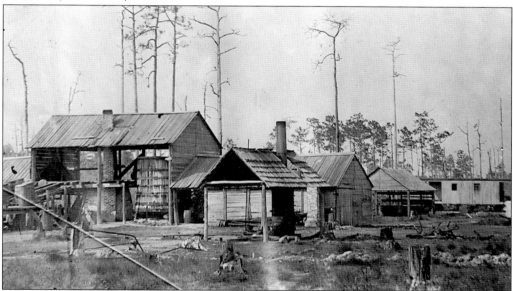

This turpentine still was located at Briggsville, later renamed Samsula. It stood near the intersection of State Roads 44 and 415. The boxcar in the background stands on a spur track of the Orange City, Blue Spring, and Atlantic Railroad. The turpentine still refined resin removed from pine trees. Opposing downward slashes through the bark blazed the pine tree. The centered downward slashes directed the flow of sap to parallel metal gutters tacked in place to direct the flow into a clay collection cup.

Settled in away from the cold North, this gentleman appears ready to rough it through the Florida winter season. Many tourists came south to escape the cold, bringing their staples with them. Many of these winter people built homes in Florida and became permanent residents.

The first fire station built in New Smyrna and the jail to the right of it were located off Live Oak Street on Anderson Street, where Fish Hospital stands now. A zoo was located on the corner of Lytle Avenue and Live Oak Street. There was an alligator, a really old lion, and some other animals. People in the area heard two things at night: the siren noting an emergency for the volunteer firemen and the lion roaring for some undetermined reason.

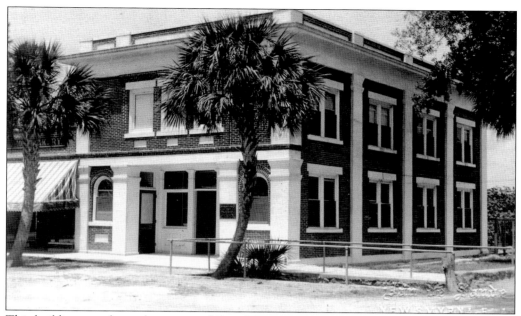

This building stands on the corner of Canal Street and Sams Avenue. It was built as a bank, but the bank collapsed when the boom burst. The first floor housed a drugstore, and the second story was offices. Davis Corner Store occupied the ground floor for years, and many of the local youth learned soda-jerking 101 under Don Curry and Burt Calhoun.

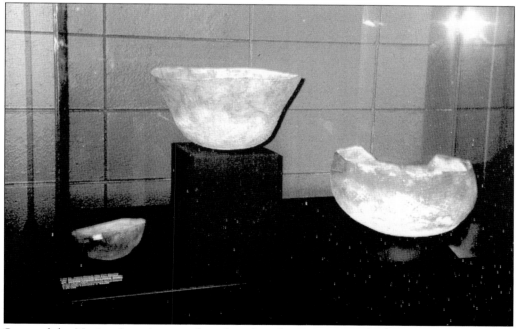

Some of the Native American artifacts found in the area are on display at the New Smyrna Museum of History. The bowl on the right was found in the Old Fort Mound and is St. Johns check stamped ornamentation. The bowl on the left was found in a mound north of town. Generally the less ornamentation on the pottery or pottery shards, the older the item is believed to be.

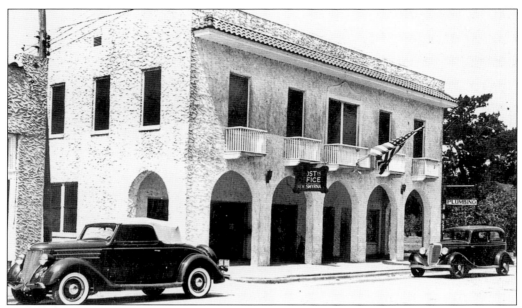

This building at 120 Sams Avenue now houses the New Smyrna Museum of History. The building was constructed during 1925–1926. Edward F. Wilson's bid was accepted to furnish a post office building. The post office was to be occupied on or before August 1, 1926. Postmaster Hayes was notified of the change to be made from the Wilkinson Building on South Hillsborough Street. The building housed the post office until 1966.

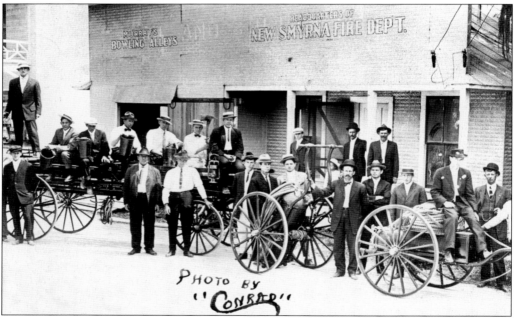

The volunteer firemen of New Smyrna pose with the town's first new fire engine on July 1, 1913. The building on the left housed the Murray bowling alley and now houses a gas company. Among those pictured are Fire Chief Hugh Moore, Dan Bell, H. Colee, Jess Ditson, Frank Fuller, Wilbur Griffin, Tom Murray, Floyd Newell, Phil Read, J. L. Rush, and A. W. Shattuck .

The state constitution of 1868 mandated basically that no child could be denied the privilege of attending school. The first schoolhouse in Volusia County was a one-room affair built to the rear of the Ocean House in New Smyrna. The surviving picture of the schoolhouse was taken a number of years after the students were moved to larger quarters. Delia Stowe of Massachusetts, who came to New Smyrna as governess for the Lowd and Sams families, became the first teacher.

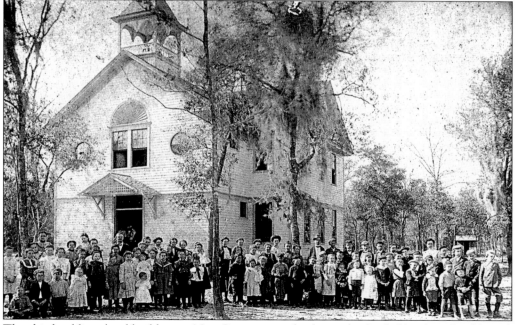

The third public-school building in New Smyrna was the first to be funded by the school board. The building was located at the corner of Mary Street and Dora Street. When the Faulkner Street School was opened in 1916, the African Americans were given this school.

Gathered together, third and fourth graders pose for their class picture in 1904. From left to right are as follows: (first row) Gladys Read, Alice Read, Ira Register, Essie Byrd, Ruth Holley, Howard Spaur, Harry Simmons, Curtis Silvers, Sadie Tedder, Bert Fuller, Cortez Brooke, and Harold Chilton; (second row) R. McIver, May Tedder, Donna Hardy, Orren Pellet, Joe Bryan, Armine Robertson, Annie Simmons, William Lourcey, Mabel Paul, Irene Harvey, Granville Read, and Burns Phillips. The teacher is Ianthe Bond (Hebel).

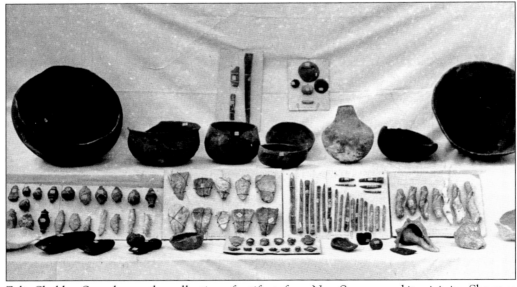

Zelia Sheldon Sams began the collection of artifacts from New Smyrna and its vicinity. She gave custodial control of the collection to her granddaughter, Zelia Mary Wilson (Sweett). When Zelia Mary was in her teens, her grandmother died, and she inherited the collection. The 100-year-plus collection is now on loan to the New Smyrna Historical Museum under the custodial care and ownership of Lawrence J. Sweett.

Five

ACROSS THE BRIDGE

Locals love the beach, and more of them would live there if they could afford the expense. In the 1930s, an oceanfront lot could be purchased for $15—if you had $15 during the Great Depression. Living on the ocean shore is delightful for a month or two in the summer, after that, the locals find it too windy; there's too much blowing sand, too much dampness, and red rust envelopes the automobile. There are sharks in the water that bite people occasionally, especially when people get among the fish the sharks feed on. When you are in or near the water, and you smell fish, this is a warning; sharks smell fish too, and they feed on fish. Leave the water and the fish to the sharks. Swimming, surfing, sunbathing, or just walking on the beach looking for seashells makes for a fine time at the beach.

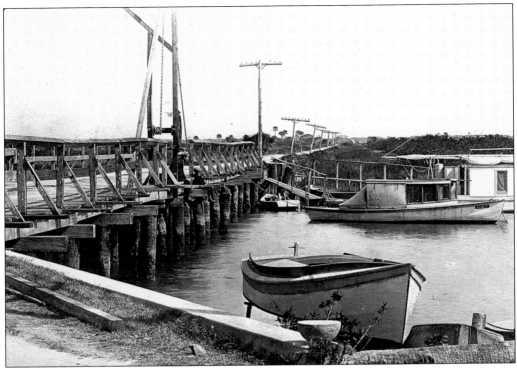

The bridge to the North Causeway was located 200 feet or so north of the present location. The causeway was straight with no curves. Men working with a dragline, shovels, and wheelbarrows dug the ditches on either side to provide the fill dirt to build the first causeway. The bridge was called Berry's Bridge because it was beside Berry's Store.

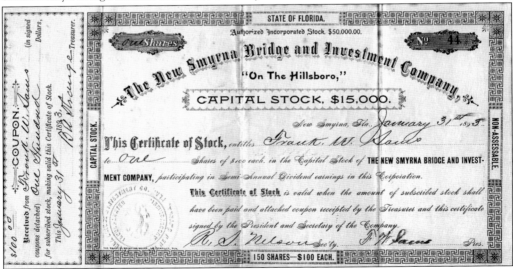

Washington E. Connor, entrepreneur, stockbroker, and sometime philanthropist, organized the New Smyrna Bridge and Investment Company in 1892 in order to finance the building of a bridge across the Hillsborough River (Indian River North) from New Smyrna to the beachside. Capitalized at $50,000, the shares were valued at $100 each.

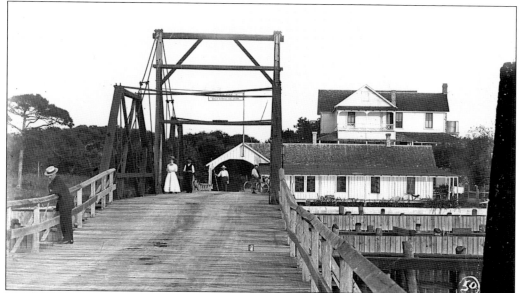

The Bridge Investment Corporation was capitalized at $50,000. The Jacksonville *Times-Union* reported an amount of $15,000 was the amount raised. A contract was awarded at $12,500. The following appeared in the *New Smyrna Inlet* newspaper dated May 19, 1892: "On May 9th at 4:30 p.m. the trip hammer on the dredge boat fell and struck the first pile of the new toll bridge." The first bridge was washed out by a hurricane in October 1892. Washington E. Connor refinanced and rebuilt the bridge, becoming the defacto owner of the bridge.

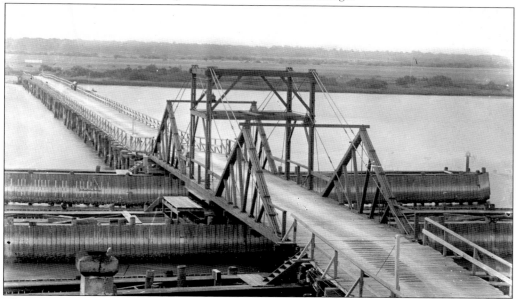

These views are of the second bridge, a much sturdier structure. Morrison Lewis was the first bridge tender. The tolls were 5¢ during daylight hours and 10¢ cents at night. Mr. S. H. Barber was the second bridge tender. Barber built a two-story house at the foot of the bridge and later jacked up the building to make it three stories. It is now known as the Riverview Hotel. A fish fry and a parade celebrated the ending of the tolls July 20, 1933.

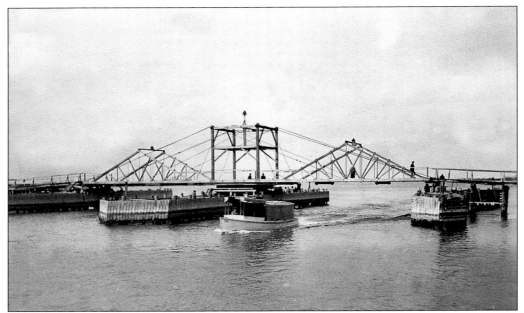

Albert Moeller's boat clears the North Bridge going south. Moeller ran a passenger boat between New Smyrna, Coronado Beach, and Ponce Park. A passenger could ride for as little as 5¢. It cost 5¢ to cross the bridge during the day, 10¢ at night. Moeller operated his passenger boat before the bridge was built and for some time afterward.

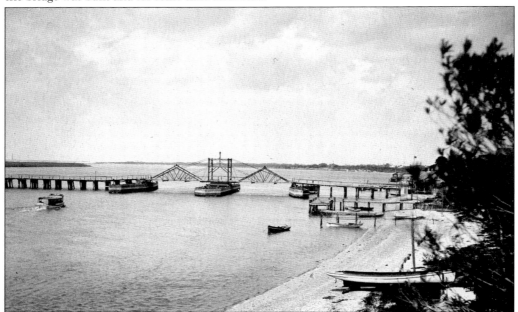

This picture was taken from the cupola on the John Detwiler home. The Detwiler house was built on a shell mound. Earlier Douglas Dummitt had a home in this area. He lived in one house and his slave and their children lived in a house nearby. Dummitt is credited with planting the first commercial orange grove in the state on Merritt Island. Dummitt was deputy customs collector during the 1830s.

Pierre Lorillard's *Cayman* anchored on the St. Johns River during one of the *Cayman's* trips from the New Smyrna base. The *Cayman* was 120 feet long and 26 feet wide with a steel hull. Her propulsion was provided by twin-screw, 200-horsepower, triple-compound engines and moved at 10 miles per hour underway. The *Cayman* had a 60-foot stable barge she towed when needed.

This is a rather poor picture of one of the reflectors recovered from the lighthouse on the south side of Mosquito Inlet that was completed in 1835. Before the lighthouse could be put into service, it was undermined by the currents at the inlet and toppled to the ground. Wildcat, a Native American chief, recovered one of the 13 reflectors and is reported to have worn it as a helmet. This reflector, perhaps the same one, was found in a swamp behind New Smyrna by a member of the Sheldon family.

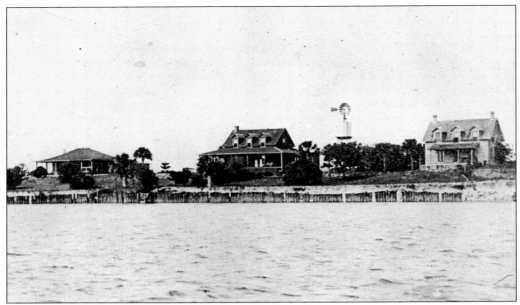

The smaller house on the left was initially the home of the pilot for vessels navigating the inlet. From his perch high on a dune, the pilot could see the ocean. Those in need of his services would signal him for assistance. He would walk across the peninsula to launch his boat and row out to the vessel. When the vessel left, he was dropped off at sea and would row back to the beach. Foul-weather navigation was not an option for the pilot.

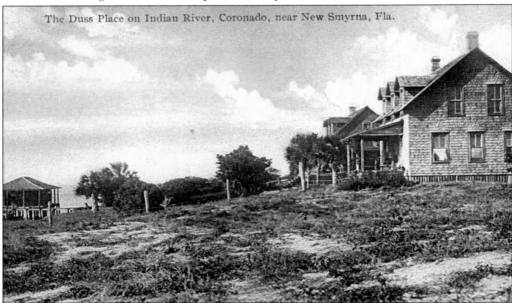

The Duss Place on Indian River, Coronado, near New Smyrna, Fla.

The Duss place in the foreground is the house on the far right in the previous picture and has substantial land between the house and the river. The previous picture shows a bulkhead between the houses with little land between the house and the bulkhead. The river current has cut deeply into the land in this area and in order to preserve the land, the bulkheads have to be in place and maintained.

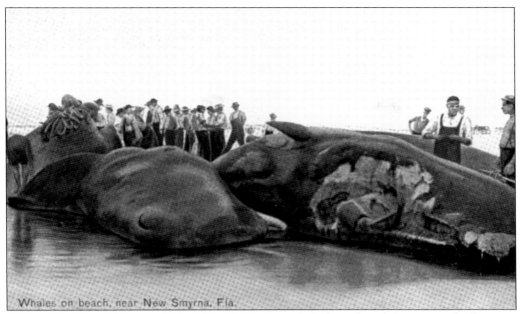

Whales on beach, near New Smyrna, Fla.

Several whales swam up to the beach and were stranded when they did not swim back out to sea. The locals gathered and, having heard tales of valuable ambergris, they cut into the whales to find such a treasure. They did not know the sperm whales usually voided the ambergris from their intestines and there was none to be found in these whales. Ambergris is used as a fixture in perfumes.

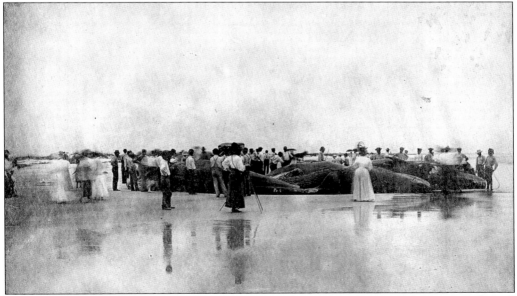

A pod of whales swam into shallow water on both sides of the inlet in 1907 or so, and they all died. Locals tried to save the whales, and when that proved impossible, some tried to salvage some whale meat. It is told that it was terrible thing to watch as people attacked the dead whales with axes and knives and machetes. The heat and the decomposition caused bloating and there were some explosions that really fouled up the butchers.

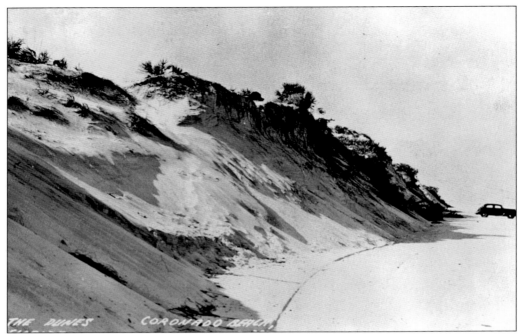

This magnificent dune line disappeared in the late 1940s as weather worked against the shoreline. The north of the Crawford Road approach did not recover until the jetties were put in place in the mid-1960s. The northerly littoral drift of sand in the area of the inlet built the shoreline back to the mid-1930s line. The dunes take much longer to build and may never attain the former height.

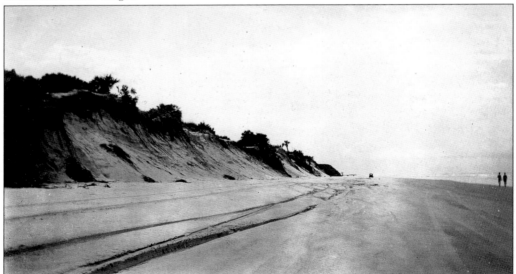

The natural dune line north of the Beachway approach is pictured in the late 1930s. The wet sand is drying and less tolerant of vehicular traffic, as evidenced by the deep tire tracks as the automobile proceeds up the beach. As sugar sand, dries the granules separate and create a natural barrier to normal vehicular traffic above the daily tide line. The wet sand compacts and makes a compatible driving surface in the tidal areas.

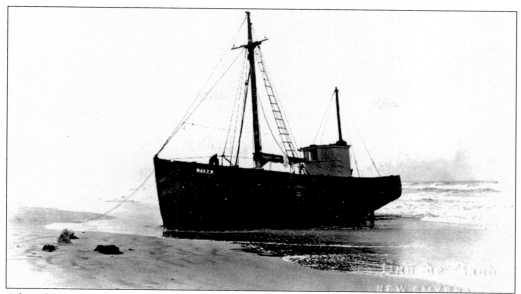

A boat has run aground high on the beach after losing power at sea. If the boat washed up during a storm, it would be pushed by a storm tide, and when the storm subsided, the boat would be high and dry. Seagoing tugs would be called, and usually they could drag the boat back out to sea. The condition of the boat determined if the boat was sturdy enough to stand the strain of being pulled across the sand to the water.

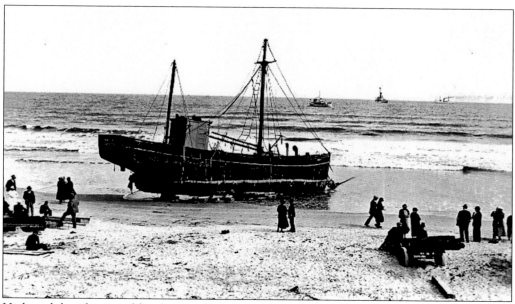

High and dry, this vessel has been pulled around in order to drag her off of the beach with the least resistance. It looks like the propeller is broken, so if and when she is pulled into deep water, she will have to be towed to dry dock. If she reaches deep water, they might find if the hull has been damaged too much to stay afloat. The hawser is in place, and the tug is getting ready to go to work. Good luck.

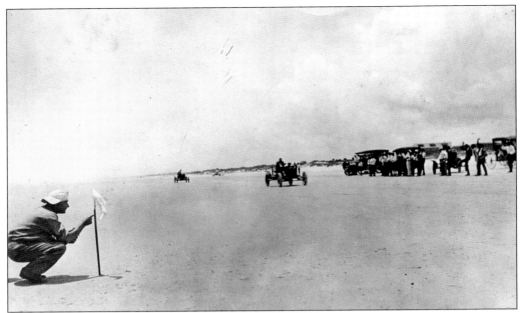

Speed week at Coronado Beach was something of a bust. There were not that many cars around, and it was hard to get them started and keep them running, much less get them to run for any distance. Speed was the thing even then, and people kept at it and are still trying to go faster and faster. The racers went north, and Daytona got lucky—or did they?

Daugherty built his pavilion/hotel in 1926. This picture shows the building before a severe northeaster damaged it. The north wing and the front of the building were severely damaged. The front of the building was rebuilt. A vertical bulkhead was constructed in front of the building. At one time, there was a roller skate rink in the basement. Later the basement was used as a bathhouse.

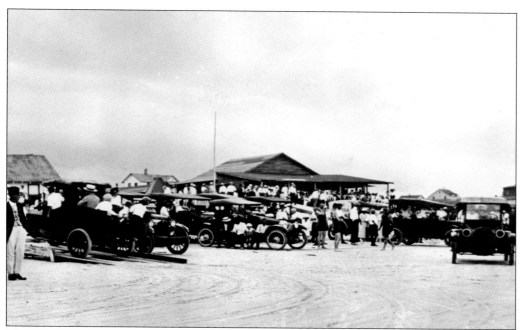

The Brann Pavilion was located at the north side of the Flagler Avenue approach. The building had toilets, showers, dressing rooms, sheltered picnic tables, and a catered area for large groups. This was a building built to serve the needs of visitors to the beach. Wayne Connor owned the building to the rear of the pavilion. The building now houses the Club Breakers.

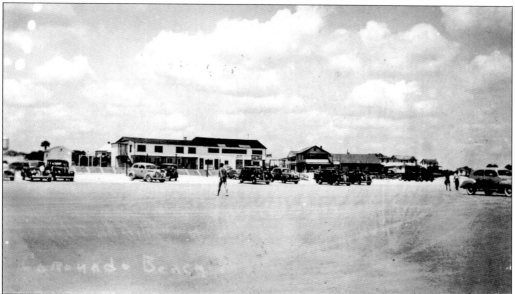

The Casino (pavilion/bathhouse), on the left at the foot of the Flagler Avenue approach, was a popular gathering place throughout its existence. It was built on pilings in 1926–1927 with a stair-step seawall tied into the approach on the north end and not tied in on the south side. The rising storm water from a 1947 northeaster got behind the seawall on the south side, washing the sand out from behind the seawall, and it tumbled. The severely damaged building was torn down.

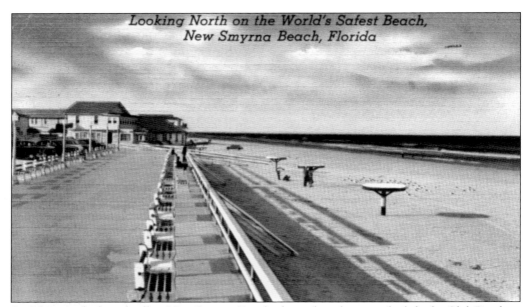

Standing on the boardwalk at New Smyrna Beach, the parking lot is on the left, the Club Breakers is the first building, and the next two buildings are no longer there. The peanut-tree shelters have transitioned from a palmetto-frond pitched roof to flat roof that served the purpose as well until they were all gone.

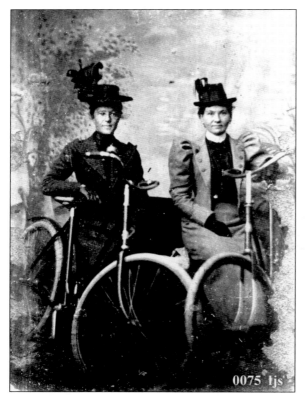

These ladies pose in front of their sturdy bicycles of the early 1900s. The dress of the times was not conducive to athleticism. Whether the bicycles belong to the ladies or not is speculation. It is doubtful if the photographer kept such props on hand in the New Smyrna of those times. There was a cycling club in town and it is a reasonable assumption the ladies were members of the club and were proud to pose with their vehicles.

This grave is in the middle of Canova Drive in New Smyrna Beach. The son of Charles Dummitt, also named Charles Dummitt, was born August 18, 1844, and died April 23, 1860. Young Charles was 16 years when he tripped over his gun and accidentally killed himself. Stories vary as to where the event occurred—from Merritt Island to near the Dummitt Mound, where his family resided. There is no question as to where he is buried. The crypt is on family property.

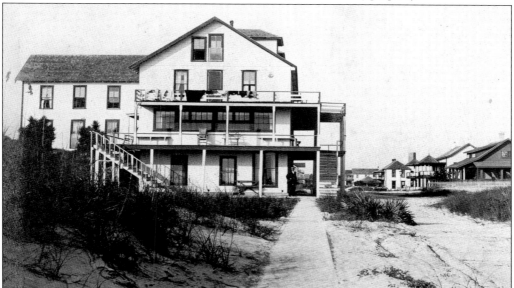

William Newell stands in the shadow of his hotel, the Atlantic House, located near the southeast end of Flagler Avenue on the beach side. Newell also established a livery on the mainland in the 100 block of Washington Street in what is now the Old Fort Park. The livery was an ancillary service to the hotel and provided hacks for transportation from the railroad station to the hotel. Whether the ride was part of the hotel service or an extra charge is not known. The Atlantic Hotel burned in 1916.

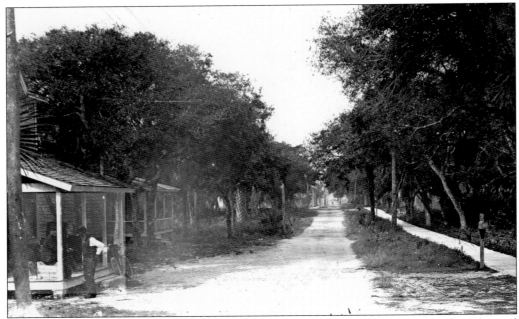

The man is standing in front of the building used as a post office after the Atlantic House burned in 1916. That building at 221 Flagler Avenue and the one next to it are still standing. The north bridge tender's house can be seen at the end of the street. When the picture is enlarged, other buildings are visible.

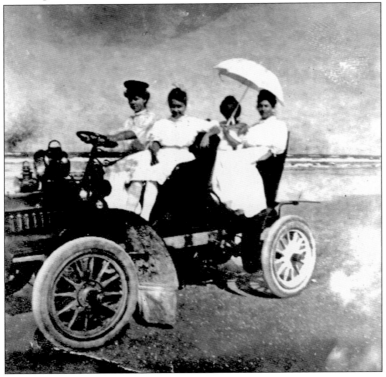

The Saxon ladies cruise the beach in the family car during the early 1900s. There is some question as to whether the beach was more dangerous for the car and the people than the car was for the beach. The car is gone, as are the ladies, while the beach remains. The damp sugar sand makes a hard surface for beach driving and as such permits the citizenry to drive on the public beach in front of some very private homes.

This service station on the beach side of Third Avenue on the beach side was built during the real-estate boom in the 1920s. It was about this time that Mr. John Musson established a nursery across the street. Paved sidewalks were poured on both sides of the side streets off South Atlantic Avenue. A number of cottages, business buildings, and oceanfront homes were built during this period of economic expansion. Every thing was booming until the real-estate boom burst.

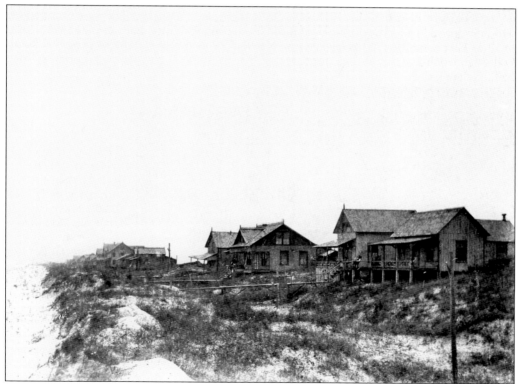

The first summer vacationers to Coronado Beach were from Central Florida. Long before air-conditioning, the only remedy for the Florida heat was a breeze. Early visitors to the East Coast passed the word about the Atlantic Ocean breezes. Later the incorporated town of Coronado Beach was north of Austin's subdivision reaching from ocean to river north from Second Avenue to the inlet.

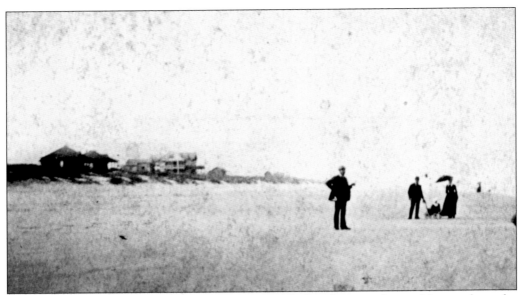

The winter visitors to the area known as Coronado Beach enjoy the cool breeze from the ocean well protected from the sun and wind by their heavy clothing. The rambling wooden buildings in the background were connected by wooden walkways built over the deep sugar sand. The large building in the background was the Coronado Hotel, the first of several hotels to bear that name.

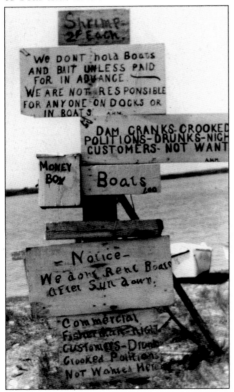

Albert Moeller owned and managed a fish camp at Turtle Mound and also served as caretaker for the historic mound. The various signs evidence Moeller's frustration with some of the people with whom he had to deal. Moeller usually sailed from his fish camp to New Smyrna, and the round trip normally took two days, sometimes more by the time he finished his business in town.

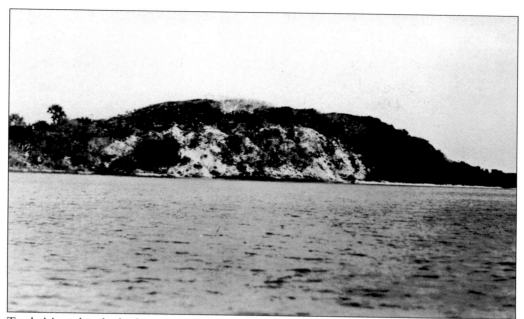

Turtle Mound is the highest natural elevation on the east coast of Florida and has appeared on navigation charts of Florida since the earliest times, but perhaps it is not "natural." It is a Native American midden composed of oyster shells and stands 40 or more feet tall. The Aiis tribe's territory, according to some reputable accounts, began at Turtle Mound and ranged south.

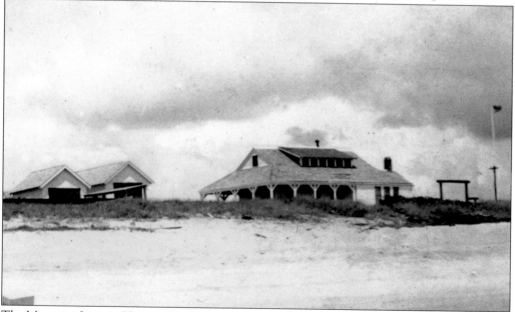

The Mosquito Lagoon House of Refuge evolved into a United States Coast Guard surf station in the 1930s. The facility was decommissioned when the Coast Guard station was constructed at Ponce de Leon Inlet in the late 1930s. The surf station was commissioned again at the beginning of World War II. Abandoned at the end of the war, the house fell prey to vandals. The paved road ends where the building stood.

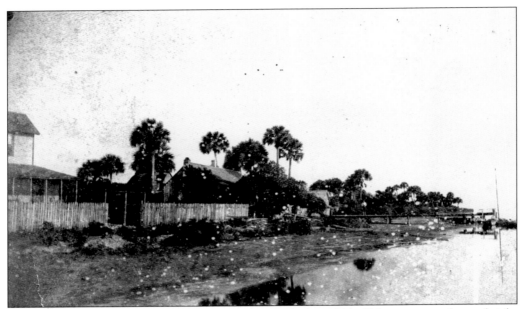

This look at Eldora along the waterfront was taken in the late 1900s. Eldora was a mail stop, freight stop, and passenger stop for the river steamers when they plied the old channel. Palmetto berries were harvested in season, honey was collected from beehives, and citrus fruit was harvested and shipped to market. Mosquitoes, snakes, and an occasional bear added to the rather quiet life of the inhabitants.

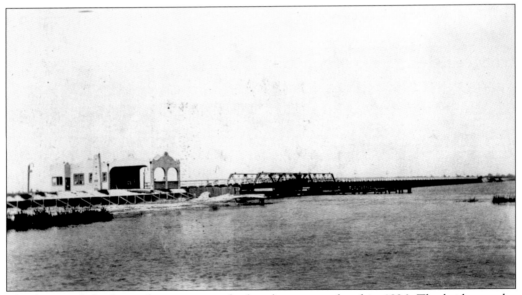

The first south bridge and causeway to the beach was completed in 1926. The bridge tender lived in the bridge house and was on call 24 hours each day. The swing bridge was operated by an electric motor. If the electric motor failed there, was a six-foot lever that was put in place, and the bridge tender walked a circle creaking the bridge open to water traffic, and then he had to crank in reverse to open the bridge to automobile traffic.

Captain Dummitt's war club was reputed to be always with him when he was in his boat or in the woods. Dummitt organized the Mosquito Roarers during the Second Seminole War, which started in 1835. He was in the battle of Dunlawton, the group's first taste of battle, which illustrated a need for further training. The club may have been a gift from a Native American friend.

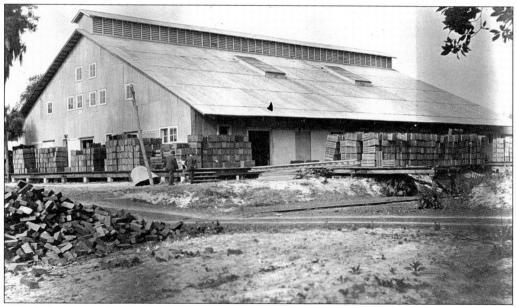

The Oak Hill Packing House was in service for many years, until the orange groves slowly disappeared from the effects of time, temperature, and development, and there was not enough demand to keep the business going. The world evolves, and people have to adjust to new challenges. The work offered at Cape Canaveral lured many qualified people to the cape, and they found careers there.

www.arcadiapublishing.com

Discover books about the town where you grew up, the cities where your friends and families live, the town where your parents met, or even that retirement spot you've been dreaming about. Our Web site provides history lovers with exclusive deals, advanced notification about new titles, e-mail alerts of author events, and much more.

Find Your Place in History.